BARRON'S ART HANDBOOKS

AIRBRUSH

BARRON'S

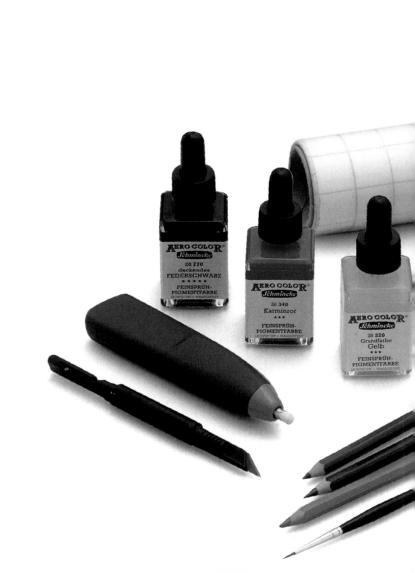

BARRON'S ART HANDBOOKS

AIRBRUSH

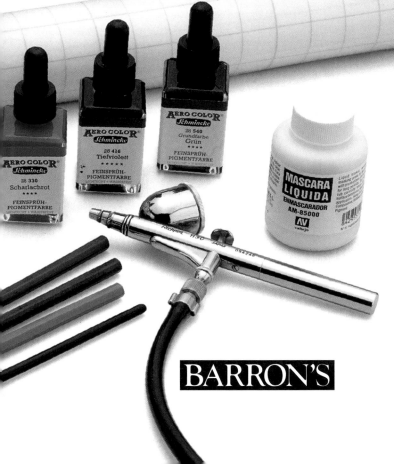

BARRON'S

CONTENTS

CONTENTS

GENERAL INTRODUCTION

Historically speaking, the use of the airbrush was limited to the retouching of photographs and commercial artwork. However, the great boom in visual media, and especially in advertising, brought about an exchange of creative ideas between the mass media and the fine arts. Nowadays the airbrush prevails as a tool commonly used by artists, although it took a long time for this to come about.

The History

The origins of the airbrush go back to 1893, when the American, Charles L. Burdick, set up a firm called the Fountain Brush Company dedicated to the manufacture of the first airbrushes. Burdick was an accomplished watercolorist who produced the first watercolor paintings to be done with an airbrush. He sent some of these to the annual exhibition of the Royal Academy of Arts, and they were rejected because they were produced by means of a mechanical device. The airbrush still had a long way to go before being accepted as an artistic medium in its own right. The American artist Man Ray identified with the Dada and Surrealist groups at the beginning of the twentieth century, and was the first continental artist (Man Ray produced all his work in Europe) to use the airbrush in avant-garde art. The artist described his experience with the airbrush in the following terms: *"The results are astonishing, they have a photographic quality even when my subjects are not in the least bit figurative... It is thrilling to paint a piece of work while hardly touching its surface, as if it were a purely mental act."* But Man

Man Ray (1890–1976), The Aviary. The Roland Penrose Foundation, Chiddingly. This is possibly the first piece of art produced with an airbrush. Man Ray was part of art's avant-garde in the 1930s.

Ray's enthusiasm was not shared by contemporary critics who reproached the artist for using mechanical means.

For many years the airbrush survived in the fields of illustration and commercial artwork, used to retouch photographs and for posters and advertisements. Full acceptance of the airbrush as an artist's tool came with pop art, a movement that appeared in 1960 and that dominated the arts and consumer goods advertising. Artists such as Andy Warhol, Tom

Miquel Ferrón, Tube of Paint. Private collection. Precision and realism distinguish the medium of airbrush.

Wesselman, and Roy Lichtenstein burst into the forefront of the international art scene with works inspired by advertising, comics, and commercial objects produced by mechanical means. The British artists Peter Phillips and Allen Jones were the first pop artists to use the airbrush on large scale works.

Under the influence of these artists, the airbrush achieved its greatest popularity. In 1972 at the Paris Biennial, works were exhibited by hyperrealist painters who produced huge, starkly realistic paintings, cold, mechanical, and seemingly photographic in technique: sharp images, gigantic portraits, blown-up details of motorcycle or automobile parts, and highly detailed townscapes. In these types of work the airbrush was revealed as an irreplaceable in-

Peter Phillips
(1939),
Painting for
a client.
Binoche
Collection,
Paris. The
use of the
airbrush took
hold in the
fine and
commercial
arts inspired
by advertising
imagery.

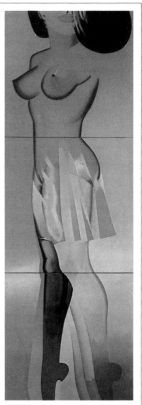

strument, capable of a precision unobtainable with any other traditional medium.

The airbrush is now fully accepted in the world of the fine arts and is used both by commercial artists and avant-garde experimenters. It is an indispensable tool for achieving ex-tremely precise images, for re-touching photographs, and for producing even tones and slick finishes used for advertising. Airbrush is a medium that offers new possibilities, either alone or in combination with other methods, taking art into new territories.

MORE ON THE SUBJECT

· Features and systems **p. 8**
· Airbrushes **p. 10**

Allen Jones (1941), Perfect Fit.
Ludwig Collection. Free-and-
easy coloring is typical of
airbrush work.

Poster Art and Advertising

Ever since its appearance, the airbrush has shown itself to be an ideal medium for creating posters and advertisements. The finish achieved with the airbrush is especially suitable for reproduction; its smooth chromatic transitions possess a quality and pictorial clarity that are difficult to attain using other art media. Precise outlines and uniformly colored surfaces are the most striking characteristics of this radically modern technique.

HIKE for HEALTH

Charles Angrave (1892), Poster. Private collection.
A poster from 1932. Although the airbrush, in
those days, had not yet been introduced in the
world of fine arts and painting, many illustrators
were beginning to discover its potential.

FEATURES AND SYSTEMS

The airbrush allows you to paint by means of a jet of liquid paint that is atomized in a similar way to aerosols, although with much more accuracy. Control of this jet of color depends on the air pressure, the consistency of the paint, and the distance between the airbrush and the support. The first of these factors can be controlled in several different ways depending on the model of airbrush. On the following pages we will look at the characteristics of each of these different types.

The Basic Mechanism

The airbrush basically consists of a nozzle through which pressurized air passes; this air carries along with it the paint contained in a cup situated near to the nozzle and atomizes it, spreading it over the surface to be painted. The control system of the airbrush consists of a finger lever that al- lows the artist to control the air flow. When the finger lever is pressed the air rushes into the airbrush and sucks up paint from the paint cup, this then mixes with the air, is atomized, and is then expelled through the nozzle. Differences be- tween airbrushes are due to different methods of control- ling the air pressure and the fineness of the jet of paint.

The airbrush works by the same basic drag-through principle, identical to that applied by simple atomizers used to spray liquids (usually fixing solutions). Upon blowing through the mouthpiece, the air causes the liquid to rise from the reservoir and be atomized at the outlet.

The result of the dispersion of color by blowing is mottled, adequate for some types of job but very coarse for most work.

Seen in cross-section, the spray mechanism is based on two tubes at right angles that supply the air and the color respectively.

The airbrush supplies air at high pressure, which causes the color to break down into fine particles and coat the surface of the paper uniformly.

Fixed Action Airbrushes

In these models, the finger lever only controls the air flow. On pressing the lever, the air intake is opened and air mixes with the paint either inside or outside the airbrush body, de- pending on whether it is an airbrush with internal or exter- nal atomization.

Airbrushes with external at- omization are the most simple, because with most of them the air flow cannot be adjusted and they are used to paint large surfaces in a uniform col- or. Some models include a needle in the air nozzle that regulates the amount of paint atomized. Spraying has to be interrupted, however, in order to adjust the needle.

In airbrushes with internal atomization, the mixing of air and paint is carried out inside the airbrush body. Upon pressing the finger lever, the air admission valve is opened

Atomizer airbrush without needle. This is a fixed action airbrush where the lever only regulates the airflow, without any direct control over the color flow.

MORE ON THE SUBJECT

- Airbrushes **p. 10**
- The parts that make up an airbrush **p. 12**
- Accessories and air supply **p. 14**

External atomization airbrush with needle. This is also a fixed action airbrush, which allows a certain amount of control over the jet of color by means of manual adjustment of the needle in the nozzle.

Internal atomization airbrush with needle that permits manual control of the air and color flow, but spraying needs to be interrupted and the needle adjusted each time.

and the air atomizes the paint and expels a greater or lesser amount through the nozzle according to the position of the needle, which can be adjusted by means of a screw situated at the back of the handle. The further back the needle is, the thicker the jet of paint will be.

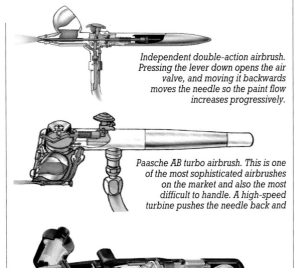

Independent double-action airbrush. Pressing the lever down opens the air valve, and moving it backwards moves the needle so the paint flow increases progressively.

Paasche AB turbo airbrush. This is one of the most sophisticated airbrushes on the market and also the most difficult to handle. A high-speed turbine pushes the needle back and

Double-action Airbrushes

Fixed double-action airbrushes allow you to control simultaneously the air valve opening and the needle position by means of a double-action trigger. The most sophisticated models (which are also the most frequently used by professionals) are the independent double action airbrushes. With these the air supply and the color flow can be regulated independently. When beginning to paint with the independent double-action airbrush, it is possible to start by projecting just air and then letting the paint flow in gradually increasing amounts in order to avoid the splashing that can occur with single-action and fixed double-action airbrushes.

Aztek 3000S airbrush. A top-quality airbrush and easy to handle, it includes a set of four interchangeable nozzles: for general use, with a wide spray, with a thick spray, and for spattering.

New Designs

Technical advances directly influence precision instruments such as airbrushes. One of the latest models, the Fischer Aerostat, has introduced a new feature in the lever that controls the airflow; control over the air and color flow is extremely precise, more so than in any other model. This airbrush is supplied with five interchangeable nozzles, including one of 0.1 mm width that gives it the potential to do highly refined work.

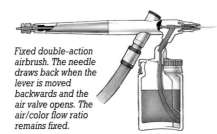

Fixed double-action airbrush. The needle draws back when the lever is moved backwards and the air valve opens. The air/color flow ratio remains fixed.

The Fischer Aerostat is the most advanced airbrush on the market, with special new features in the airflow and the color supply. It includes a set of five interchangeable nozzles.

AIRBRUSHES

On these pages a popular sampling of airbrushes is shown from the wide range that exists on the market. The latest models are getting more and more stylized and sophisticated and incorporate greatly improved mechanisms that allow for great precision. From among the various models, the professional should choose one that is best suited to need and technique. Very sophisticated equipment may simply have more capacity than is necessary, or practical. For the uninitiated, it makes sense to start with a simple and economical model and move on to more complex airbrushes as need requires.

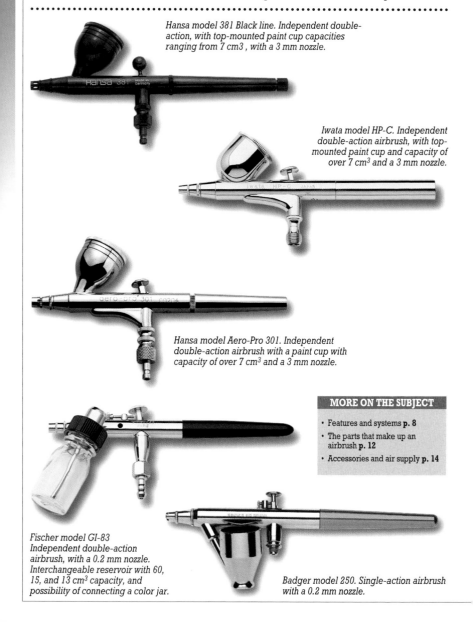

Hansa model 381 Black line. Independent double-action, with top-mounted paint cup capacities ranging from 7 cm3 , with a 3 mm nozzle.

Iwata model HP-C. Independent double-action airbrush, with top-mounted paint cup and capacity of over 7 cm^3 and a 3 mm nozzle.

Hansa model Aero-Pro 301. Independent double-action airbrush with a paint cup with capacity of over 7 cm^3 and a 3 mm nozzle.

MORE ON THE SUBJECT

- Features and systems **p. 8**
- The parts that make up an airbrush **p. 12**
- Accessories and air supply **p. 14**

Fischer model GI-83 Independent double-action airbrush, with a 0.2 mm nozzle. Interchangeable reservoir with 60, 15, and 13 cm^3 capacity, and possibility of connecting a color jar.

Badger model 250. Single-action airbrush with a 0.2 mm nozzle.

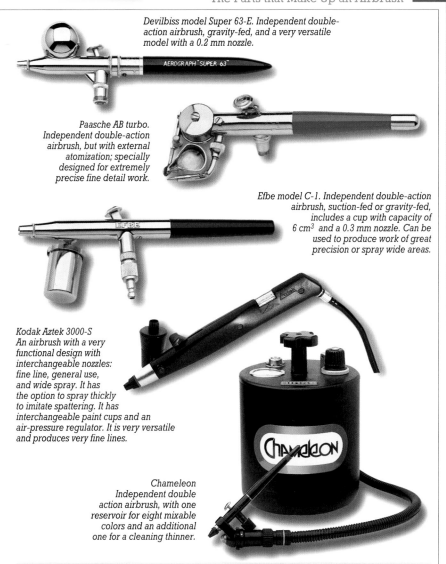

Devilbiss model Super 63-E. Independent double-action airbrush, gravity-fed, and a very versatile model with a 0.2 mm nozzle.

Paasche AB turbo. Independent double-action airbrush, but with external atomization; specially designed for extremely precise fine detail work.

Efbe model C-1. Independent double-action airbrush, suction-fed or gravity-fed, includes a cup with capacity of 6 cm^3 and a 0.3 mm nozzle. Can be used to produce work of great precision or spray wide areas.

Kodak Aztek 3000-S An airbrush with a very functional design with interchangeable nozzles: fine line, general use, and wide spray. It has the option to spray thickly to imitate spattering. It has interchangeable paint cups and an air-pressure regulator. It is very versatile and produces very fine lines.

Chameleon Independent double action airbrush, with one reservoir for eight mixable colors and an additional one for a cleaning thinner.

Different Adaptations

Some models of airbrush adapt to professional needs by means of changing the color intake, allowing changing from suction-fed to gravity-fed. In the sophisticated Chameleon model, the airbrush is used independently and is coupled to a paint cup.

This is the Chameleon airbrush shown separate from its reservoir canister. This option allows it to be used like a conventional airbrush.

THE PARTS THAT MAKE UP AN AIRBRUSH

Most airbrushes have similar mechanisms and all are based on the same principle. The fact that some airbrushes are gravity-fed and others are suction-fed has hardly any influence on their mechanisms, which are all based on an air inlet system, through a hose, combined with the movement of the needle that opens and closes the outlet for the pulverized paint.

Working Systems

Essentially, the airbrush has not undergone many changes from the time of its invention to the present day. Its design has been updated and it has been stylized, its finish is smarter and more streamlined, but the basic structure of its main parts (like the control lever, which precisely directs the air jet that atomizes the paint along the needle, and the nozzle, where the color expands, pushed by the jet of air) already existed in the first airbrush design created by Burdick in 1893.

Independent of whether they are fixed or double-action airbrushes, the basic components are always the same. The airbrush consists of a body that contains a valve through which the air is supplied, and a reservoir containing the color. In the case of gravity-fed reservoirs (with the paint cup above the airbrush), the paint receptacle may form part of the airbrush body or it may

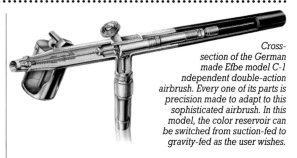

Cross-section of the German made Efbe model C-1 independent double-action airbrush. Every one of its parts is precision made to adapt to this sophisticated airbrush. In this model, the color reservoir can be switched from suction-fed to gravity-fed as the user wishes.

take the form of a fairly large cup. A handle protects the internal mechanism and the needle and eases handling of the apparatus. On top of the airbrush body there is a lever that controls the air and color intake.

In suction-fed airbrushes, the color receptacle is situated by the side or below the body. These models have the advantage of being able to contain much more color than gravity-fed airbrushes, and reservoirs of different colors can be quickly substituted and also easily cleaned. On the other hand,

they are more cumbersome and not as well balanced as the gravity-fed cups, limiting slightly your freedom of action.

Airbrush Maintenance

To keep your airbrush in perfect working condition, it is important to take great care not to damage the nozzle, as it is delicate and easily damaged by impact. It has to be absolutely clean, and the needle must be able to pass, without any obstruction, through the hole.

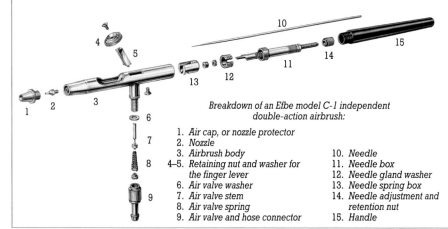

Breakdown of an Efbe model C-1 independent double-action airbrush:

1. Air cap, or nozzle protector
2. Nozzle
3. Airbrush body
4–5. Retaining nut and washer for the finger lever
6. Air valve washer
7. Air valve stem
8. Air valve spring
9. Air valve and hose connector
10. Needle
11. Needle box
12. Needle gland washer
13. Needle spring box
14. Needle adjustment and retention nut
15. Handle

The control lever must work perfectly while the spring has to exert the correct pressure. If the spring lacks proper tension, the airbrush will lack the control necessary to do fine work. In addition, the needle retaining screw must be fully tightened so that the needle does not move during the process of painting.

Reservoirs

Airbrushes can have different types of paint reservoirs, depending on whether they are gravity-fed or suction-fed. Many gravity-fed airbrushes incorporate a paint cup as part of the interior structure of the tool's metal body that cannot be dismantled. Cleaning is carried out by filling the reservoir with water and spraying until it comes out completely clean. Several airbrush models have detachable reservoirs that make for easy cleaning.

Adjusting the Needle

Nowadays manufacturers are substituting the traditional threaded nozzle for a floating nozzle. The threaded nozzle allows no paint leakage, and as it adjusts to the pressure the needle always remains exactly in the center. With these models it is unwise to dismantle the needle during cleaning as the adjustment pressure could be affected.

The modern floating nozzle provides the needle with a perfect fit, functioning much as a rapidograph does.

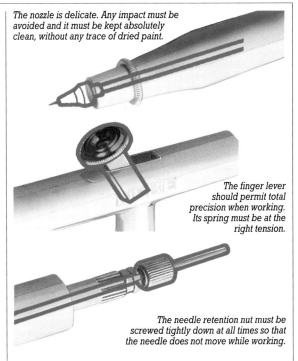

The nozzle is delicate. Any impact must be avoided and it must be kept absolutely clean, without any trace of dried paint.

The finger lever should permit total precision when working. Its spring must be at the right tension.

The needle retention nut must be screwed tightly down at all times so that the needle does not move while working.

Another important advantage of these reservoirs is that they make it easy to change colors quickly without having to clean; you just exchange one paint reservoir for another.

MORE ON THE SUBJECT

• Features and systems **p. 8**
• Airbrushes **p. 10**

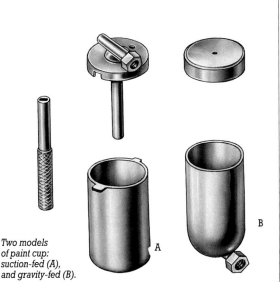

Two models of paint cup: suction-fed (A), and gravity-fed (B).

ACCESSORIES AND AIR SUPPLY

In addition to the airbrush itself, there are accessories necessary for its use. These may be of diverse quality and price. The choice of accessories will depend on the artist's needs and the quality of the airbrush.

Accessories

One of the advantages of the airbrush is that the artist controls and creates effects without having to keep changing mechanical accessories. The accessories that are necessary to the operation of the airbrush are: the hose, the adapter for attaching the hose to the air supply, a moisture filter, and a pressure gauge to control the air pressure.

Hoses connect the airbrush to the compressor by means of airtight fasteners. Hose lengths vary from approximately 3 feet to 10 feet, and are made from a variety of materials. Vinyl hoses are the cheapest but also the most fragile as they may crack and get constricted. Taped rubber hoses are longer lasting although they are heavier than vinyl. The latest models of hoses are made up of artic-

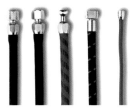

The vinyl hose (right) is the most fragile. On the left, reinforced and nonreinforced hoses: the most frequently used in airbrushing.

Two types of adapters for attachment to the compressor: with outlets for five (above) and three (below) airbrushes.

ulated rings, which are light but very strong and durable. The hose connects to the airbrush and the compressor by means of threaded adapters. These may be simple, for connecting one airbrush, or multiple, to work with more than one airbrush at a time.

Advertising and graphic artists may use multiple adapters to work with two airbrushes simultaneously.

The moisture filter and the air regulator are usually incorporated into the compressor. If not, or in the case of using cylinders, cans of compressed air, or

diaphragm compressors, they can be obtained separately. The air regulator regulates the air pressure. The moisture filter eliminates moisture that accumulates with condensation due to the high air pressure in the compressor.

Air Supply: Compressors

Compressors are pumps that take in air, compress it to a set pressure, and release it through an outlet. The two essential factors that determine the characteristics of a compressor are its air intake capacity, which is measured in liters per minute (l/min), and the maximum air

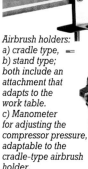

Airbrush holders: a) cradle type, b) stand type; both include an attachment that adapts to the work table. c) Manometer for adjusting the compressor pressure, adaptable to the cradle-type airbrush holder.

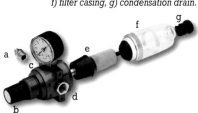

Parts of a manometer: a) air-outlet coupling, b) adjustment knob, c) manometer, d) pressure regulator, e) moisture filter, f) filter casing, g) condensation drain.

The Parts that Make Up an Airbrush
Accesories and Air Supply
Use and Maintenance of Your Equipment

15

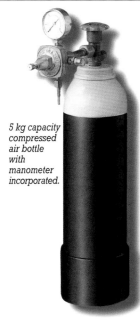

5 kg capacity compressed air bottle with manometer incorporated.

Can of air with 500 cm² of propellant.

ity. Apart from compressors, there are other solutions for supplying air: cans with 500 cm³ of compressed air may solve the problem but they are short-lasting, and compressed-air bottles are efficient but can only be refilled in specialized establishments. Leaving aside these not very usual means, all compressors can be classified in two groups: diaphragm compressors and reservoir compressors.

Diaphragm Compressors

These are the simplest of compressors: they compress and release the air without storing it, only working when the intake and compressor pump are functioning. They are small-sized machines, simple and economical, but with great inconveniences. They are noisy and they tend to overheat when they are in use for a long period, so work has to stop and the machine has to be switched off. They do not generally produce a steady outlet pressure and the paint spray may be inconsistent.

Reservoir Compressors

These are fixed to the upper side of a reservoir where compressed air is stored. In these machines the tank pressure is always greater than the outlet

Sagola model 777, diaphragm compressor. Supplies a pressure of 3 atmospheres and an airflow of 450 l per minute.

pressure, so the user always has a steady supply of air that is adjustable by means of a valve. The most modern compressors have an automatic pressure control that allows the reservoir pressure to be fixed so that the compressor switches off when the preadjusted pressure is reached.

pressure the air can reach inside the compressor. The air pressure on the walls of the air tank is measured in kilograms per cm² (kg/cm²), or in atmospheres (an atmosphere being the equivalent to a pressure of 1 kg per cm²). The airflow, measured in liters per minute, that a compressor can supply is directly proportional to its intake capac-

Compressor Mechanisms

The reservoir compressor mechanism is based on a piston that draws the air in until the required pressure is reached. At that point the motor stops until the pressure drops again. It provides the airbrush with a constant supply of air. The diaphragm compressor does not store air but compresses and releases it.

Internal view of a reservoir compressor (left) and a diaphragm compressor (right).

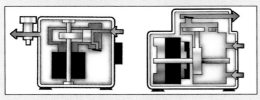

15 Plus-A automatic reservoir compressor, with a 1.5 l tank and 15 l per minute outlet airflow. This is a high-performance silent compressor.

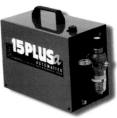

MORE ON THE SUBJECT
• Features and systems **p.8**

USE AND MAINTENANCE OF EQUIPMENT

However simple an airbrush may be, it requires careful attention on the part of the user. Bear in mind that it is made up of complex mechanical parts and precision mechanisms. Ideally, an airbrush should be used by one person, who is responsible for its care and maintenance. There are basic rules for using and maintaining the equipment that should be followed in order to keep it in good working order.

Using Your Airbrush

The following are some basic directions for handling an airbrush. Hold the airbrush in your hand the way you would a ballpoint pen, between your thumb and middle finger, moving the finger lever with your index finger. The body of the airbrush should rest comfortably in the hand as if it were a writing instrument, but with careful attention to holding the airbrush correctly in order to precisely manipulate its effects. Beginners often try to find the most comfortable way of holding the airbrush and adopt bad habits. This should be avoided

in order to obtain best results. Once you are ready to paint, you should test the result of pressing down on the finger lever to obtain a flow of air only. If any color appears during this operation, the needle will have to be adjusted to fit perfectly in the nozzle. To obtain a jet of color, the lever is pulled backwards while pressing down at the same time. Adjustable stands are made that can be fixed to the work table to hold your airbrush securely and prevent it from falling on the floor. Some of these stands will accommodate two airbrushes, allowing the user to comfortably alternate from one to another.

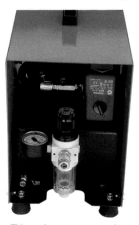

This modern compressor shows the start/stop switch (the round switch at the top right) and the manometer indicating the air pressure at the outlet.

MORE ON THE SUBJECT
• Accessories and air supply **p. 14**

The illustration shows the correct way to hold the airbrush, like a writing instrument, using the index finger to control the lever.

It is important to avoid acquiring bad habits when handling the airbrush and not hold it in the way that at first appears to be the most comfortable.

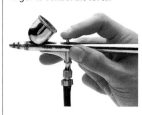

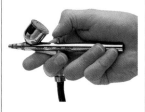

Pressing down on the finger lever activates the air supply.

Pulling the lever backwards opens the flow of color for spraying.

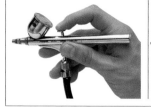

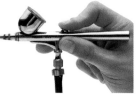

Caring for Your Airbrush

An airbrush that is not properly cared for will not function effectively. It will become an uncontrollable instrument. The key to its maintenance lies in the thoroughness with which it is cleaned and cared for, a process that takes some time and attention. It is important that it be cleaned after every use, even light use. Even when it has only been used for a few minutes, it must be cleaned. Otherwise, you run the risk of clogging that can damage and

The Airbrush Always on Its Stand

The airbrush is a delicate instrument and care has to be taken to look after it. During the work session it is very important to get accustomed to leaving it on its stand when not in use, and so prevent it from falling, which could seriously damage its mechanism. Set up on its stand, the airbrush is ready for use and out of harm's way.

If the airbrush is to be left to one side momentarily during a work session, it should always be replaced on its stand.

disable the action of the brush. Additionally, the paint in the cup must be of the right, creamy consistency; an airbrush is incapable of eliminating or expelling congealed paint. Thirdly, the air pressure must never exceed the levels set by the manufacturer. Lowering it to achieve a spatter effect causes no damage, but a pressure that is too high not only produces a bad result but may also damage the couplings and the washers in the air valve.

Caring for Your Compressor

All manufacturers of compressors supply a manual with specific instructions for correct use and maintenance. It is very important to check the oil regularly; if this is not done frequently, the compressor may seize up, which means an expensive repair job. For this reason, the oil level should be closely monitored, as failing to do so will cause expenditure and inconvenience. The oil gauge is on the side of the compressor with a level indicator and filler cap; the level should always be above the indicated mark and the oil should be thoroughly changed at least once a year. It is important that only the types of oil recommended in the instruction manual be used. Different models of compressors need different types of oil. Mixing incompatible oil types can cause serious damage. The moisture filter should be regularly emptied; if the compressor has a reserve chamber or tank, the drain key should be used regularly to eliminate excess moisture. The air intake filter should also be checked frequently and cleaned when necessary. The machine should always be upright and on a flat base. In many countries there are strict regulations regarding the storage of compressed air.

To comply with safety requirements, reservoir compressors must pass inspection before sale and have a screw that, when loosened, provides access to the air chamber for this purpose. It is advisable that compressors have a certified inspection mechanism.

Electric eraser working off two 1.5 volt batteries. Spare erasing rubbers of different grades of hardness are available.

Erasers

When you need to lighten a shade, whether to create highlights or to open up white spaces in a colored area, an ordinary eraser can be used as long as the sprayed color is not too resistant. There are special, very abrasive erasers on the market, which erase almost any kind of paint if only small areas need to be rubbed out. The conventional eraser, the eraser pencil, and the electric eraser (working off 1.5 volt batteries) can reduce color tones easily. A common way of erasing with the airbrush is by using white paint over a colored ground; the resulting effect is embroidery-like, with the advantage that the support is left undamaged.

Color fading with a conventional eraser.

Erasing done with a rechargeable pencil eraser.

Erasing done with an electric eraser.

CLEANING THE AIRBRUSH

Cleaning your airbrush is an essential part of its maintenance. It should be cleaned every time you change colors and at the end of every work session. Good cleaning assures long life for your equipment. The best work results are achieved when your airbrush is clean and well maintained. The cleaning process has to be thorough and the user has to take care not to damage the parts when dismantling and reassembling.

Before Changing Paint

Any residual paint left in the airbrush will affect the new color. Loose particles of pigment must not dry and harden inside the nozzle as this will cause blockages or damage the mechanism. The air and paint outlets are very fine and are easily blocked, even by very small amounts of dried, residual paint. In the best case a noticeable reduction of accuracy occurs and in the worst, the airbrush can be put out of action.

After using one color, the air has to be expelled in order to get rid of all the paint remaining in the chamber. This can be done by spraying on a piece of paper or on a rag until no more paint is expelled and the air jet is clean. Next the paint cup is filled with water, or a suitable thinner for the paint being used. Now continue to spray until all the solvent has been expelled. Repeat until you are sure that no trace of paint remains. If you have used acrylic paint, it is advisable to clean the airbrush

first with water, then with acrylic solvent for a final cleaning. In the case of cellulose lacquers, their corresponding thinners should be used. All paints based on a solvent other than water should be cleaned with the thinner recommended by the manufacturer or with a universal solvent.

After Every Session

Again, it is important to get into the habit of cleaning your airbrush after every session. Even when the airbrush has only been used for a few min-

utes, it must be cleaned. If it is not cleaned immediately, paint may dry inside one of the parts, making cleaning difficult. The cleaning process starts with dismantling the air cap and removing the needle with great care. In order to do this, the finger lever must be pushed forward and the needle then extracted and cleaned with a damp cotton cloth, taking great care not to bend it. (Even if the thinner came out clean when sprayed through, some paint may have remained on the needle). The needle is then placed back in the airbrush very carefully so as not

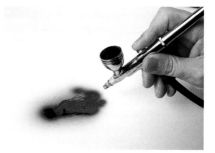

After finishing work, all the remaining paint must be expelled from inside the airbrush.

The airbrush is soaked in water and the lever is pressed so that the paint is removed from the inside of the paint cup.

The lever is depressed once more, with the cup filled with water, so that the jets of air and water clean out the remaining paint.

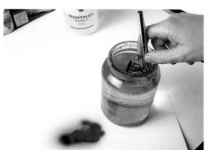

Use and Maintenance of Equipment
Cleaning the Airbrush
Table of Faults, Causes, and Solutions

19

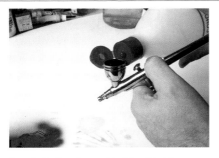

In order to clean thoroughly, it is advisable to add a few drops of alcohol to the reservoir in order to remove any remains of paint.

Scrub and clean the inside of the paint cup and the airbrush head with a stiff-bristled paintbrush.

to blunt or twist it. Be sure that, when returning the needle to its place, the finger lever is pushed forward and pressed down so that there is no contact between it and the needle. Next the nozzle is unscrewed and cleaned with a paintbrush moistened with the right thinner and by blowing through it. It is then left to dry, screwed back into place, the air cap replaced. The airbrush can now be returned to its stand ready for the next session.

Many professionals leave the nozzle in water overnight,

Lastly, expel the liquid and repeat as many times as necessary until you have confirmed that your airbrush is perfectly clean.

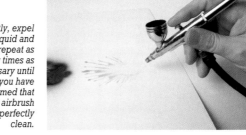

though this is not recommended and may even be damaging. The best way of

removing accumulated paint is by spraying the right solvent with the airbrush at full pressure. If the nozzle is still not clean, the residues can be eliminated with a cotton cloth or with a paper towel. If the inside of the nozzle continues to be blocked up, you can try using an old airbrush needle, twisting it very carefully inside the nozzle and cleaning it from time to time as explained previously. But remember, the internal parts of the airbrush must be handled as little as possible.

The Need to Clean Thoroughly

It is not always necessary to dismantle your airbrush completely and check the state of each and every part. When painting with watercolors or fine, soluble pigment, a cleaning of the outside is generally sufficient. If you are working with acrylics or with paints that require thinners other than water, then the airbrush must be dismantled and its basic parts cleaned separately.

Thorough cleaning is absolutely necessary after using acrylic paint or other substances that require organic solvents.

MORE ON THE SUBJECT

• The parts that make up an airbrush **p. 12**

• Use and maintenance of your equipment **p. 16**

TABLE OF FAULTS, CAUSES, AND SOLUTIONS

The table included here relates common problems that may occur while working, their possible causes, and the best solution for each one. Some of these problems simply stem from lack of practice and inconsistancy of use and are usually easily remedied. Others may have more serious mechanical causes and may require repair by a professional.

	FAULT	CAUSE	SOLUTION
	Blots are left.	Color too watery. The airbrush is too near the paper. Needle is too far back.	Thicken the color. Move the airbrush further away to reduce the force of impact. Rectify the position of the needle and secure it in place.
	Splashes occur.	Insufficient air pressure. Color too thick or incorrectly mixed. Particles of pigment inside the nozzle or the airbrush body.	Adjust the pressure. Empty and clean the airbrush; rectify the mixture. Strip down the airbrush and clean thoroughly.
	Splashing at the beginning and end of a line.	The lever is released too quickly.	Release and press the finger lever more gently.
	Irregular lines.	Unsteady handling of the airbrush. Nozzle obstructed.	Practice until you get steadier. Clean the nozzle.
	Lines are too wide.	Worn out needle. The nozzle or the air cap are incorrectly placed.	Replace it. Remove and replace correctly.

Precautions: Before starting to spray, especially at the beginning of a job, it is a good idea to begin each spraying away from the area to be painted, in order to avoid patches and splashes due to accumulations of paint that occur when triggering the airbrush.

Before each spraying operation the paint should be sprayed out onto a separate piece of paper in order to avoid splashing due to accumulations of paint in the nozzle.

	FAULT	CAUSE	SOLUTION
	The lever does not return to its initial position after pressing it.	The valve spring is not tense enough. The lever is broken.	Stretch or replace the spring (professional repair job). Professional repair job.
	The needle is blocked inside the airbrush.	There is dry paint inside. Damage due to bad handling.	Submerge the airbrush in water and carefully unblock the needle. Professional repair job.
	Paint flow is interrupted.	Paint too thick. Needle too tightly adjusted in the nozzle. No paint in the cup. Broken finger lever. Dry paint blocking the nozzle.	Dilute the paint. Separate the needle and check the retention nut. Fill it. Professional repair job. Dismantle and clean the nozzle and the needle.
	Air pressure is too high.	Compressor air outlet too open.	Reduce pressure.
	Air escapes from the nozzle and forms bubbling.	Loose or incorrectly placed air cap. Air pressure too low.	Adjust the nozzle correctly. Increase pressure.
	Air escapes when the airbrush is not in use.	Air valve rod badly adjusted, or the diaphragm is broken.	Professional repair job.
	Air leaks from the connections to the air supply.	Connections are loose or worn.	Adjust or replace the connectors.
	Compressor overheats.	Lack of lubricating oil.	Add oil to the level indicated.

MORE ON THE SUBJECT

· Use and maintenance of your equipment. **p.16**

COLOR

The colors that are used for painting with an airbrush can be divided into two large groups: transparent and opaque. The choice of one or the other will determine the result of the work. Opaque colors are solid tones that are needed when clarity of detail is essential. Transparent colors allow for more subtlety in effects and transitions, particularly appropriate for freehand work. The choice will always depend on the kind of look and finish desired.

Opaque Colors

These solid colors will completely cover the support as well as paint over other colors without their showing through. Frequently used are gouache or tempera. Both are water-soluble; gouache is available in tubes. Tempra is available in jars. The latter are somewhat thick (tubes of gouache are creamier) and have to be diluted slightly with water until the required consistency for the airbrush is obtained. If the gouache is too watery, it covers very little and irregularly and if it is too thick, it blocks the nozzle of the airbrush. However, there are gouaches that have finer pigments, such as those manufactured by Schminke, Talen, or Lefrance, and that do not form lumps. When preparing the colors, their covering capacity must be taken into account as they vary from pigment to pigment. Cadmium pigmentation (yel-

By using gouache colors, you can cover a blue surface with yellow without these blending. This is accomplished by repeated spraying of the yellow.

lows, oranges, and reds) covers quite well but other colors, such as veridian green or alizarin crimson, are slightly transparent, particularly when they are used over a darker tone. In these circumstances, it is advisable to add a small quantity of white to the mixture. It is extremely important to clean the airbrush after each use. These kinds of colors can be cleaned with water.

Acrylics

Acrylic colors have a wide acceptance among professional airbrush users. There are two different types of acrylic colors with varying degrees of viscosity. Those of a lower viscosity are diluted with water and those of a higher viscosity require a special medium.

Transparent Colors

Whichever medium is used, transparent colors require a particular work sequence. The color must be laid down in order of the darkness of pigmentation, working from light to dark. Darkening, as well as increasing color saturation, is accomplished by using successive layers.

Surfaces obtained by applying consecutive coats of an opaque medium. The opacity of the medium allows you to put light colors on top of much darker ones.

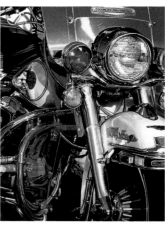

Hideaki Kodama, Harley Davidson Motorcycle. This illustration is a very fine example of how to obtain shine and the contrast of surfaces by using opaque colors.

Transparency effects with liquid watercolors. The optical mixtures give the result an intense luminosity.

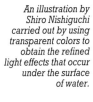

An illustration by Shiro Nishiguchi carried out by using transparent colors to obtain the refined light effects that occur under the surface of water.

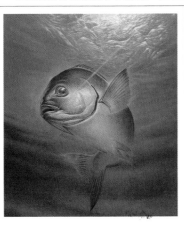

Transparent colors allow for distinct color sprayings which, when superimposed, create mixed optical effects.

In addition, for color to remain transparent one must omit the use of white, as gouache and tempera whites are opaque. The color of the paper must be utilized to keep the color light. Less dense spraying will allow the paper (whether white or tinted) to show through. This kind of work requires some precision, as well as the use of careful planning for use and sequence of color and whites. Using finishing touches of white to indicate shine and reflection, relying on the opacity of the white, is the last step.

Transparent media can be classified in the following way: traditional watercolors found in a tube, liquid watercolors, liquid dyes, and special liquid colors for airbrushes. The watercolors and the liquid dyes are ideal for the airbrush user; they can be used exactly as they come out of the container or they can be diluted with distilled water. Bear in mind that some intense watercolors may be subject to fading if they are exposed to direct light for long periods of time.

MORE ON THE SUBJECT

• Oil and cellulose colors **p.24**

Special Colors for Airbrushes

There is a wide range of liquid media that have in common the fact that they are non-toxic acrylic solutions with a high concentration of pigment, making them color intense. They have a very fine consistency and will not block the airbrush nozzle. Once dry, they are water and light resistant. Used without white (opaque color), they offer considerable transparency. They are available in containers of concentrated color, with a dropper, which require dilution, or colors that may be used directly. Generally these colors should be diluted by using distilled water. Some brands manufacture liquids to clean the airbrush, and lacquers that give a stable film of luminous color.

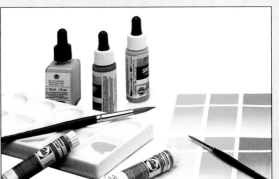

Special colors for airbrushes in containers with a dropper. The colors have extra-fine pigment incorporated to aid the flow of color from the airbrush.

OIL AND CELLULOSE COLORS

The use of the airbrush is not limited only to illustrations or pictorial works of art but it also has multiple artistic applications from painting constructed models to painting semi-industrial products. This kind of work calls for particular kinds of paint. The mediums most frequently used are oil and cellulose paints.

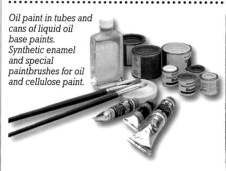

Oil paint in tubes and cans of liquid oil base paints. Synthetic enamel and special paintbrushes for oil and cellulose paint.

Papier-maché figure painted with oil paints and sprayed with gloss varnish.

Oil Paint

It is well-known that the best support for oil paint is canvas. However, the materials that can be used to support oil paints are many: wooden boards (with the correct primer), plastic material (polyvinyl compounds, acetates, and acrylic compounds), ceramic material (tiles, porcelain, earthenware, stoneware), metal sheets, and even glass. Paper is not recommended (if it is not suitably prepared) because the oil that the paint contains can stain and damage the fibers.

In order to obtain the correct viscosity of the oil paint, you have to dilute the paste that comes out of the tube with turpentine; a few drops of a drying medium can be added to these substances as oil paints contain a slow-acting drying medium. For those colors of a normal density, a 50% solution is usually sufficient to ensure a uniform jet of paint.

Although oil colors are opaque, some of them when slightly diluted can give considerable transparency. These colors, which in some catalogs are described as lacquers, are usually cadmium yellows and red lacquers (cadmium reds), alizarin crimson, veridian green, ultramarine blue, and some purples. With these you can obtain slick, smooth transparent effects on porcelain, earthenware, metal, and glass.

Cellulose Paint

Cellulose paints, more commonly known as synthetic enamels, are suspensions made up of material with pigments in cellulose lacquers and nitrocellulose solvents. These have a wide range of industrial uses, and are applied using a spray gun. Cellulose paints and lacquers are used to paint furniture, automobiles, and toys. They are used in the construc-

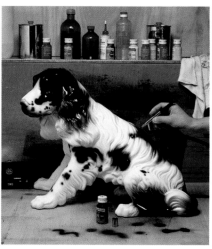

Ceramic figure painted with cellulose paint using an airbrush freehand.

MORE ON THE SUBJECT
- Color **p. 22**
- Basic practice **p. 32**

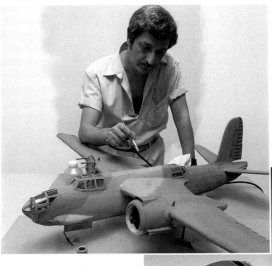

Painting a model with an airbrush using enamels. The airbrush smoothly covers its contours and crevices.

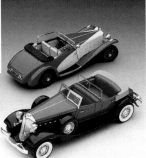

These models demonstrate the perfect finish that is obtained when working with an airbrush and cellulose paint.

tion industries and as hobby paints; for example, for model painting. They are also used in the restoration and decoration of ceramics.

Characteristics such as hardness, drying time, and shine will depend on the kind of application used. These paints are sold in containers ranging from large cans of 10 lbs or more, to small bottles of approximately 1 fluid oz. of cellulose lacquers, which some manufacturers call ceramic enamels. Once dry these lacquers are extremely hard and shiny. All of them cover surfaces very effectively and dry very quickly. When working with lacquers, clogging must be guarded against. Once some enamels harden they are very resistant to the action of solvents. Cleaning of the airbrush should be carried out before any drying has occurred and with strong solvents of the nitro type. However, careful precautions should be taken as these solvents are highly flammable, volatile, and toxic. It is important to wear a mask when working with these substances. Keep in mind, as well, that nitro solvents can damage some plastics and even dissolve them and that not all of these are suitable as thinners for cellulose paint.

Enamels for Modeling

Modelmakers tend to use enamel colors especially made for airbrushes when working with their miniatures. These fine pigment enamels, available in a wide range of colors, enable the modelmakers to achieve a high level precision finish. Enamels are, however, extremely volatile, and can dry out, even in a closed container, after a period of time.

This model has been painted with special enamels. The colors, applied with an airbrush, realistically imitate the patterns on the original.

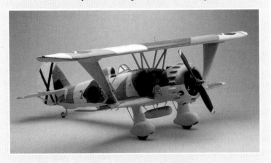

AUXILIARY EQUIPMENT

In addition to an airbrush and a compressor, the artist will need other items of equipment. There are many tools and materials that will contribute to the work's end result. Experience and style will determine which tools will best serve the artist's needs.

Paintbrushes

Paintbrushes are indispensable tools when working with an airbrush. They are used for the finishing touches and to portion the paint into the airbrush reservoir, as well as to aid in cleaning. To paint finishing touches, a sable-hair paintbrush is highly recommended. This is a fine quality paintbrush, the bristles of which form a fine, flexible point, helpful when line precision is needed. These paintbrushes can be costly but, if treated correctly, last much longer than those made of other materials. However, when painting with acrylics and using masking rubber, you should use paintbrushes with synthetic bristles as these products could leave dry deposits between the hairs.

It is useful to have a wide range of brushes of varying qualities and shapes available in order to do all kinds of work. For the airbrush artist, the most useful brushes are round with a fine tip for details. A brush of average size can be used to fill and clean the airbrush.

Selection of seven sable-hair paintbrushes of different thicknesses. Sable-hair is the best quality and also the most expensive. As an alternative, you can use mixed bristle paintbrushes, which also perform well.

Cutting Knives

Cutting knives and craft knives are also essential tools as these are needed to cut out masks. The most usual kind of cutter is one that has a ceramic blade and an interchangeable head. It is easy to handle due to its light weight and because its blade remains sharp practically forever. It only needs to be replaced in the case of breakage. A knife with a revolving head is the best one for cutting curves. An ordinary cutting knife is essential to cut paper and cardboard supports.

When cutting paper, cardboard, or masks, this should be done on a rubber or plastic mat so that the surface of the work table is not damaged. Vinyl mats are available that help to take the necessary measurements when cutting.

Stencils

These are pieces of perforated plastic that are used to draw geometric shapes and figures without having to use rulers or compasses to calculate the measurements. There is a wide range of stencils available in the form of circles, squares, ovals, triangles, arrows, numbers, letters, and so on. A special type of stencils are those called French curves. These are used as a guide for a great variety of irregular or regular curves. The stencils

Different kinds of knives. From top to bottom: knife with an interchangeable ceramic head and permanent blade; knife with revolving head to cut curves: craft knife with disposable blades; craft knife with large blades to cut thick paper and cardboard.

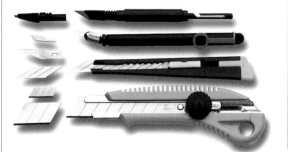

Set of French curve templates, which are needed when drawing all kinds of curved forms.

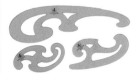

A selection of stencils with signs, ellipses, circles, and squares that aid the drawing of geometric shapes.

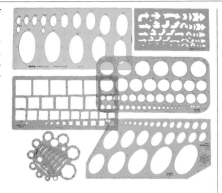

MORE ON THE SUBJECT

• Accessories and air supply **p. 14**

dissolving the color with a brush that has been dipped in water.

Other Equipment

An airbrush user will also need to have the following material available: transparent and opaque adhesive tape, large scissors for cutting paper, erasers, graduated rules and metal rulers to use when cutting with knives, a set of "T" squares and triangles, removable glue for mounts, self-adhesive masks and polyester paper for mobile masks, a magnifying glass for small details, fountain pens, a compass, a drawing pen, a rubber cement pick-up to get rid of the rubber cement, and masking liquid.

Marking Pens

Marking pens can be useful for touching up and to enhance details of the finished work. The colors are transparent and the majority of brands manufacture a wide range of tones. It is practical to have available marking pens of different thicknesses of insoluble and water-soluble ink.

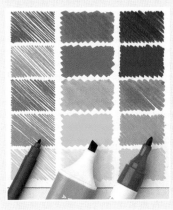

Marking pens of different thicknesses. The ink of the marking pen can be soluble in water or can have an alcohol base. The color produced by the marking pens adapts very well to airbrush work.

This picture shows the usual auxiliary equipment used when working with an airbrush, from scissors and cutting mats to pens, compasses, erasers, adhesive tape, rulers, and masking fluid.

and the French curves are used to draw and to cut out mobile masks or templates.

Graphite and Colored Pencils

Soft graphite pencils such as 4B or 8B are suitable to use when doing loose sketches of outlines, while for the tighter, definitive drawing, a medium graphite pencil such as HB or B is best.

Colored pencils are usually used to practice different mixtures of colors and tones, but they can also be used to touch up and color in details of the

finished work of art. Watercolor pencils allow you to water down the lines and to blend by

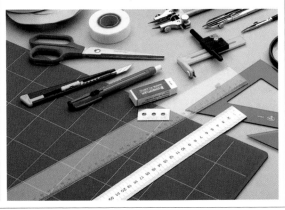

SUPPORTS

Any kind of surface can be used as a support when working with an airbrush.
However, sometimes this support will need special preparation to adapt it for
use with a particular paint. It's important to look into the possibilities
that different qualities of paper offer, as well as those offered by wood, canvas,
metal, plastics, ceramic, and glass. Finding effective ways to work with a variety
of supports takes some experimentation.

Paper

Paper supports are, to a large extent, the ones most used by airbrush artists. Most commonly used is both smooth and matte paper of the Bristol type. There are also special papers particularly suited for use with airbrush that are offered by many manufacturers. Grattage, Canson, and Schoeller make excellent papers for airbrush use. Look for paper that has a weight above 120 lb to prevent large sheets from losing shape or warping. It is also advisable to mount paper on a wooden board. Some kinds of paper come already mounted on board, which makes for a surface that will not warp or change shape and that also provides an attractive presentation. But keep in mind that board will not bend and therefore cannot be used with a scanner to reproduce original work (standard practice in laser reproduction of originals). A scanner needs a support that can be

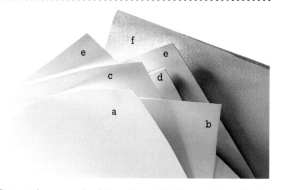

Paper and supports of varied quality suitable for use with an airbrush. A) Glossy Schoeller Durex, b) Matte Geler, c) Bristol, d) Schoeller card, e) Basik paper by Guarro, f) canvas. It is recommended that a weight of greater than 120 lbs. be used to avoid unevenness or damage when using masking.

rolled around a cylinder without causing creases or cracks in its surface. For certain types of artwork, you can use fine- or medium-grain surface paper (always with a heavy weight) and textured papers that imitate canvas for oil painting. Whatever the case, texture is a vari-

able and the artist should always be aware of the effects it can produce. Textured papers are used for more painterly works in which freehand airbrushing plays a predominant role. There are also quite unique effects that such textured papers will produce.

Glossy Schoeller Durex paper. Its glossy surface gives a special look to the airbrush spraying; a perfect finish and a high degree of luminosity.

Rough watercolor paper. The airbrush brings out the characteristic texture of this paper.

Cloth paper support. Some artists use the texture that the weft in the cloth affords as a way of obtaining specific effects.

Photographic Paper

In some commercial illustration, airbrush is used directly on a photograph. For this purpose either glossy or matte paper can be used. Both types accept gouache, the medium that is frequently used for this purpose. Matte paper, which is thicker than glossy paper, is better for large-scale work as it does not easily warp or lose its shape. It can be mounted easily, can be scraped, and readily accepts the application of gouache with a paintbrush.

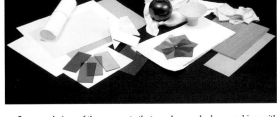

A general view of the supports that can be used when working with an airbrush. The choice of one or another will depend on the kind of work to be done. Some surfaces will require preparation so that paint will adhere properly to the surface. A variety of supports are displayed in the photograph, including different types of paper, glass, metal, plastic, canvas, wood, and cloth.

Wooden Boards

Wooden and plywood boards are good supports for the airbrush user as fine art work usually requires one or more coats of primer and a thorough polishing to waterproof its surface and make it uniform.

One of the more common primers when working on wood is *gesso*, which is a substance made up of gypsum, chalk, or another whitening medium mixed with an acrylic glue. After applying various coats, the surface can be sanded and polished until it is completely smooth. It is then ready to be painted with different kinds of paint, including those that are water-based. *Gesso* surfaces are usually slightly absorbent.

Canvas

Canvases that are primed and prepared for painting with oil or acrylic, either stretched on wood frames or mounted on board, are widely used for airbrush painting. There are many types of canvas on the market, from very fine linen to cotton ducks that vary from fine to coarse. The texture of canvas will influence the finish of the paint and should be considered for the effects it will produce.

Metal and Plastic

Metal and plastic can be painted with an airbrush provided that a compatible medium is used. Sheets of aluminum, copper, acrylic compounds, tin, as well as acetates and polyvinyl chloride, are frequently used supports.

Ceramic Materials

An airbrush or airgun may be used to paint ceramic pottery, which may even be fired when dry. Airbrush is also used on ceramic when restoring surfaces and for ceramic decoration that is not meant for firing.

All of the above mentioned materials require the use of compatible paints. In general, water based paints (gouache, watercolors, acrylics, etc.) do not adhere well to nonporous surfaces. For these surfaces a cellulose or other type of enamel paint is more appropriate.

Trying Out Different Surfaces

The effects that can be obtained with an airbrush depend directly on the grain of the surface being worked. There is a great variety of papers on the market of varying thickness and texture. It takes some experimentation to discover the range of interesting and surprising effects they can produce.

Because of its texture, the grain of either medium or thick watercolor paper can influence the final result of a work of art.

MORE ON THE SUBJECT

· Oil and cellulose colors **p. 24**

THE STUDIO, FURNITURE, AND ACCESSORIES

The artist's studio is often located in the home, equipped with all the necessary equipment and material to produce the artist's work. As in any artist's studio, space and light play an important role. But an airbrush artist's studio is highly technically equipped as well. In these pages we will re-examine the necessary accessories for the well equipped airbrush studio.

The Workshop

A large, well ventilated space, 15 square feet or so, is advisable, since spraying produces suspended particles of paint that are toxic and can be harmful to breathe. Constant renewal and circulation of airflow is essential. If fresh air is not available, an air extractor must be installed.

The work table is central. Its design and size will vary according to model. Excellent tables come in many price ranges. The table's surface can be either horizontal or tilted at a slight, perhaps 10°, angle. There are angled drawing boards available that have a mechanism that allows them to be installed on a horizontal table. This board should be solid and reinforced for the sake of stability.

Placing the Compressor

The compressor can be stored in a conveniently sized closet or compartment that has suitable exits for the hoses. During operation it is important that the closet be well-ventilated to avoid overheating. Another type of setup employs an auxiliary table with wheels that holds the compressor and airbrush support equipment. This table can also be used to store paint and other small items. Because of its mobility it can be conveniently positioned.

Utensils

The studio should have an easel for painting as well as for displaying large-sized pieces. A cork board will display color samples. A chest of wide, deep drawers will store paper, board, and original art. A variety of cabinets will store boxes of marking pens, various sized paintbrushes, stencils and curves, adhesive film for masks, and all kinds of other materials. Moveable lamps and an adjustable stool are also important pieces of equipment. It is extremely helpful for a studio to have running water to make clean up convenient.

Other Accessories

A photocopier is a useful accessory for enlarging and

A light table should form part of every airbrush artist's studio equipment.

This is an ideal set up for the airbrush studio, with necessary furniture and plenty of space for each activity.

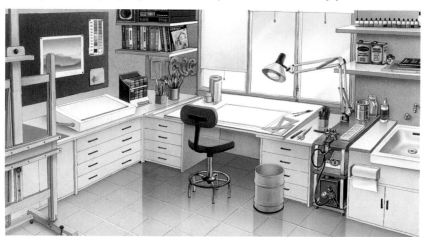

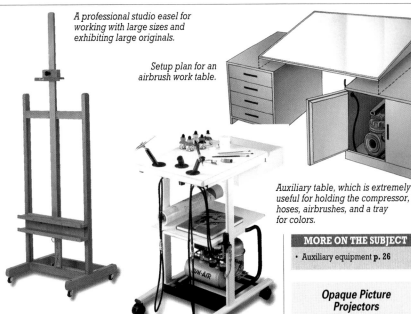

A professional studio easel for working with large sizes and exhibiting large originals.

Setup plan for an airbrush work table.

Auxiliary table, which is extremely useful for holding the compressor, hoses, airbrushes, and a tray for colors.

MORE ON THE SUBJECT

• Auxiliary equipment **p. 26**

Opaque Picture Projectors

An opaque picture projector will project a printed image. It is very useful when a transparency is not available. The opaque projector allows the artist to trace an image onto paper propped on an easel or fixed to a wall.

reducing originals and to make templates and masks. Pieces that are too large for a copy machine to handle can be done in sections, then taped together. Because a copy machine is an expensive piece of equipment, and because they are readily available commercially, a studio copier is a con-venience, but not a necessity. Originals can also be enlarged by using a slide projector. Opaque projectors are another possibility for projecting images of photographs, drawings, prints, etc. Another extremely useful accessory is a light table, which makes the task of redraw-ing originals much easier.

The opaque picture projector allows you to project any kind of small or medium-sized printed image.

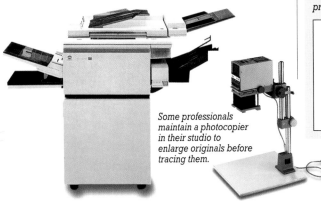

Some professionals maintain a photocopier in their studio to enlarge originals before tracing them.

A slide projector is another means for tracing originals.

BASIC PRACTICE

Prior experience in painting with a paintbrush is directly applicable to the use of an airbrush. Similar to using any paintbrush, the airbrush should be held loosely, balancing it in the curve of your hand, between thumb and middle finger. Holding the airbrush in this way gives the tool stability while leaving the index finger free to control the lever that activates the air flow. The following practice exercises are routine but essential to become familiar with airbrush use.

Straight Lines

To practice drawing straight lines, support the airbrush on a ruler that is raised at an angle from the paper at the ruler's far edge. Draw the line from right to left without a break. Be sure to hold the ruler steady as you work to ensure that the line is straight.

Curves and Circles

To paint curves, the movement is carried out by the wrist, while with circles, the whole

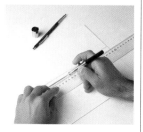

To practice drawing straight lines, the airbrush is supported on a ruler that is raised at its far edge.

When raised mobile masks are used, fuzzy outlines will occur by lifting the mask over the support.

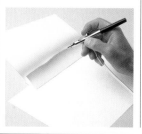

arm moves. With practice your technique will improve. By maintaining a uniform distance from the support, the line, too, will be uniform. These exercises are similar to any drawing exercise, and all such background will tend to facilitate work with an airbrush.

Dots

This exercise consists of aiming the airbrush at a specific part of the paper, activating the lever with care and then mov-

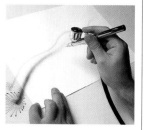

Freehand drawing of curves of different thicknesses.

ing the airbrush backward and forward, approaching and moving away from the paper to obtain thinner or thicker dots. This exercise can be done with small bursts of color or by applying a continuous jet.

Even Backgrounds

To obtain a background of uniform color, the airbrush should be held about 5 or 6 inches from the surface of the support. The position of the

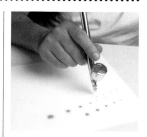

Dots made by placing the airbrush at different distances from the support.

needle should be sufficiently open so that the spray will be wider. The airbrush should be moved steadily from right to left, avoiding build up of paint at the sides; this can be achieved by going past the area you wish to cover with paint, painting well beyond its limits to the taped or masked edge.

Fixed Masks

In order to practice with fixed masks, you can simply cut out a piece of paper and place it on the support. It is a good idea to place some weights on the paper so that it will stay completely flat. You can also use a removable adhesive. Then the paint is sprayed. When the mask is lifted, a perfect negative of its image will be left in a field of the color sprayed.

Raised Masks

Fuzzy outlines can be obtained using raised masks.

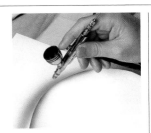

Using a fixed circular mask, slightly displaced, to obtain a fuzzy outline.

To achieve this the mask has to be raised over the surface; the further away, the fuzzier the outline will be. You can practice this by using several different kinds of raised masks with straight, curved, or torn edges.

Fading Color

Fading, or graduating, a color requires a certain amount of skill. The artist should have practice in basic airbrush techniques, as well as some drawing experience. To begin with, the edges of the paper should be masked with tape that will also hold it to the support. To achieve a gradual fade effect the color should be sprayed from left to right, then from right to left, separating the sprayings more and more, while at the same time pulling the airbrush further away from the paper. The airbrush should not stop over any one area; the rhythm of motion must be constant to prevent the formation of areas of more and less density that would mar a smooth finish. This will produce a graduated tone that moves from saturated color to the white of the paper, working from the darker area to the lighter. You can further increase the tone by going back over the area you wish to be most concentrated, working evenly until the desired density is achieved. If working vertically from top to bottom, the lower part of the paper should

Self-adhesive and Polyester Masks

A self-adhesive mask is made up of an adhesive plastic film protected by backing paper. The film should be removed from the backing paper before being used as a mask. When the mask is placed over the support, it will stick to the surface. This type of mask is used for work with glossy paper. When a grainy-surfaced paper is to be used it is preferable to use a polyester mask; this is fixed with rubber cement, which, when removed, does not damage the image. The dried rubber cement can be easily lifted by using a rubber cement pick up.

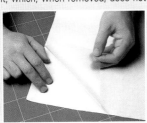

A self-adhesive mask has a removable backing paper that can be either transparent or opaque.

be left completely white. To produce a tone that is intense at the center then fades as it radiates outward, spraying should begin at the center, then lighten evenly on all sides. Again, go back over the center to concentrate color until desired intensity is achieved. Always keep the airbrush moving so that

there are no sudden jumps in color. Once the desired result has been obtained you can superimpose new colors, fading and blending gently, using the airbrush in the same way.

MORE ON THE SUBJECT
· Illustrated examples of masking **p. 36**

Spraying should be done from right to left, left to right, pulling the airbrush further away from the support, stopping when the color is very faint.

To obtain a smooth, gradual fade, begin from the top of the paper and spray horizontally.

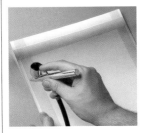

Incorrect fading effect; color lightening is not uniform. Irregularities and sudden jumps appear in the spraying.

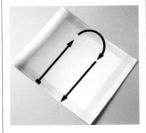

A correct fade. The graduated color is even, progressing without any jumps.

MASKS

Masks are protectors that are used to limit the action of the color. Masking, or the protection and reserving of spaces on the illustration, is a fundamental part of airbrush work. The technique of masking is an art in itself; it means planning the work and dividing it into distinct stages. The precision that airbrush work demands cannot be achieved without the masking process. Masks can be classified as fixed, moveable, raised, or liquid.

Fixed Masks

A fixed mask is one that adheres to the support. A self-adhesive film is usually used for this type of masking. This type of film is especially made for airbrush work and is available in loose sheets or in a roll. It is backed with protective paper

The basic idea of masking can be illustrated by sticking some adhesive tape to the paper that you are going to paint.

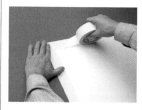

When spraying the paper, the tape protects the margins.

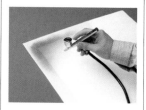

When the tape is removed, the edges of the tape are perfectly defined.

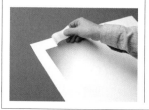

Different kinds of materials used for masking: a) adhesive masking tape for margins, b) absorbent-type cotton or cotton batting to achieve a vaporized effect, c) polyester paper for moveable masks, d) liquid masks, e) rubber cement for mounting, f) torn paper to give irregular edges, g) stencils for ellipses and geometrical shapes, h) roll of self-adhesive masks.

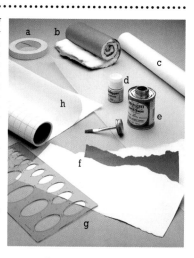

that must be gradually removed when applied to the support. In spite of its strong adhesive, which effectively blocks the color, it can easily be removed once the work is finished. In addition, the self-adhesive film is thin enough to prevent the color from accumulating around the edges and so the outlines of the negative image are sharp and clear. The film's transparency allows you to see through to the masked illustration. The film's surface will accept drawing. Another kind of fixed mask is polyester paper. This mask does not have a protective backing and is applied using rubber cement. Although this material requires the added step of gluing, it gives excellent results.

Moveable Masks

Moveable masks are applied to supports by holding them down with one hand with a weight, or by holding them at a distance from the support to create soft edges. Moveable masks can be made out of any material;

By applying an absorbent cotton wool mask, a cloud effect can be produced. This can be held by hand while spraying color.

The result that is obtained is almost always unpredictable as the jet of air moves the cotton but the result is convincing.

paper, board, torn cardboard, stencils, and French curves. The artist's fingers or the palm of the hand can also be used.

Raised Masks

A raised mask can be held at any practicable distance, near or far, from the support. It can also be fixed with rubber cement or pieces of rolled tape. Absorbent-type or unprocessed cotton can be used as a raised mask; when it is sprayed, the color filters through it, producing a fade effect that lends itself to the representation of clouds.

Liquid Masks

Liquid masks are used to reserve spaces for small details. Rubber cement or other com-

Adhesives for Moveable Masks

Sometimes, adhesives can damage the paper's surface on removal. This can also occur on a sprayed base coat of color. A light bonding rubber cement can be used for such delicate surfaces when used for moveable masks. On finishing the masking and spraying process, the mask is removed and the glue that still adheres to the paper can be easily removed with a rubber cement pick up without damaging either paper or color.

To eliminate the dry rubber cement, rub over the area with a rubber cement pick up, which does not damage the paper.

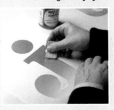

A simple example of the use of an adhesive mask. Cut a piece out of the mask, remove the protective paper, and lay it onto the support.

Sprayed color that covers the paper and overlaps the mask.

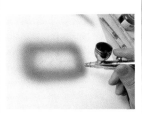

mercial liquid mask products are applied with a paintbrush. These masks dry quickly and leave a film that is easily removed by rubbing with a cloth, your finger, or a rubber cement pick up when paint is dry. It is not advisable to apply a liquid mask with a sable brush, as when the rubber dries it sticks to the base of the bristles and is difficult to remove,

The liquid mask is applied with a sturdy bristle brush, one that won't easily be damaged by the masking.

Rub away the mask once the paint has dried.

After removing the mask, the white area is sharp-edged and clear.

making the brush unusable. A brush with synthetic bristles used for this purpose must be immediately cleaned with rubber cement thinner or other solvents compatible with the liquid masking product.

MORE ON THE SUBJECT

• Illustrated examples of masking **p. 36**

Spraying over a dry mask.

Once removed, the remaining configuration exactly reproduces the brushed-on mask.

ILLUSTRATED EXAMPLES OF MASKING

Masking, in its various forms, allows complex airbrush work to be carried out. It is important that the artist be familiar with these resources before beginning a complex job. Liquid, fixed, and moveable masks each have their applications. These pages contain practical demonstrations to illustrate some of the possibilities offered by a variety of masking techniques. Using these in combination will produce high precision results.

A Liquid Mask

A liquid mask is used to reserve small shapes, silhouettes, dots, and small-sized lettering. This material can be an effective tool for highly detailed sign painting, small- to medium-sized. Moveable masks are more suitable for larger areas.

The rubber cement or masking fluid is applied over outlined lettering, using a very fine brush for small detail. Then the area is sprayed with the airbrush. When the color has dried, the mask is removed with a rubber cement pick up. The negative image of the lettering will be perfectly defined. Working with liquid masks and airbrush offers all the precision of a paintbrush, and the sleek, flat finish of sprayed color.

Stencils

Stencils are useful complements for masking. You can use an eliptical stencil to paint the upper surfaces of cylin-

ders. The airbrush must be moved so that it goes over the edge of the stencil. To obtain the correct fade and coating, the brush must be kept in motion past the inner edge of the stencil so that the color does not accumulate or form into puddles at the stencil's edges.

A Raised Mask

One of the simplest raised masks is the artist's own hand. Depending how close the hand is placed to the support, the

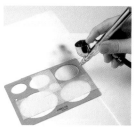

Stencils can be used as direct raised masks. This is the easiest way of obtaining geometrical shapes.

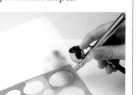

The artist's own hand is the most elementary raised mask that can be imagined. The hand can be used to achieve looser, soft-edged effects.

A paper doily used as a raised mask. Such items can be used to achieve decorative effects.

result will be sharp or fuzzy. Another frequently used source is that of perforated paper. The holes in the paper can create interesting designs when they are sprayed using the airbrush. Any kind of object that has an irregular shape is a potential raised mask; torn or cut out paper is useful for masking. Absorbent or unprocessed cotton produces interesting fuzzy effects.

A liquid mask, applied with a paintbrush, can be used for sign painting, which needs highly detailed freehand painting.

Transferable Lettering

Another way to create negatives of lettering is to use transferable lettering. Taking the appropriate measurements and ruling lines for the letters to sit on, the sheet of transferable lettering can then be placed on the support, each letter pressed on by using a hard, round point. The area is then sprayed with color. The letter forms are then removed from the support with tape once the color has dried. A negative image of the letters remains, outlines clearly defined. In order to get the maximum results when using this method, measurements should be taken beforehand to ensure that the letters are perfectly aligned.

Moving a Mask

One mask can be moved and reused to obtain transparent and shaded effects. Any mask made of paper can produce repeated images, lending itself to create more

Transferable lettering is a commonly used mask for sign-painting jobs.

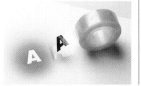

Once it has been sprayed with color, the transferable lettering is removed with a piece of tape.

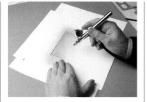

Using the same mask, overlay effects can be obtained if the mask is placed and replaced in different positions.

The same mask can be used to obtained different shading depending on its distance from the support.

complex configurations. Patterns of transparency can be produced by various superimpositions.

Shading

Masks are not only used to reserve areas of paper but also

MORE ON THE SUBJECT

• Masks **p. 34**

The results will be more complex the more the mask is moved.

Masking with a ruler will obtain perfectly straight shading.

to produce convincing shading. Using, for example, a stencil with circles or oval shapes, the shading of a sphere can be created by first slightly raising the stencil, then holding it nearer to the support in the area where darker shades are required, and spraying to intensify the illusion of volume.

Types of Paper Needed

Again, for a complex job, the artist will need a great number of masks. These can be pre-made objects and materials, or paper shapes designed by the artist. For this purpose papers of all qualities and textures as well as varying thicknesses are useful. Anything the artist can conceive of can be fashioned and shaped from paper to use as a mask.

Lower quality paper can be made into interesting masks. By tearing it into different shapes, you can obtain irregular edges.

USING LIQUID MASKS

A liquid mask is a simple system of reserving white spaces (or base color), which enables you to define small areas before using the airbrush. It is applied with a fine paintbrush and dries quickly. Once you have finished spraying, the mask can be removed by rubbing with a rubber cement pick up. Liquid masking can be used in combination with other masking techniques.

Approach

A strawberry is a classic subject that requires the use of a liquid mask. The small seeds and puckers that give texture to its surface can only be reproduced by using masked spaces made by a paintbrush. The mask should be applied with a bristle or synthetic paintbrush that comes to a point and is flexible enough to use for fine work. Again, this type of sturdy brush will handle masking fluid or cement, while sable will not. After a careful drawing is made and the colors for the painting determined, larger areas of masking should be cut out and applied. Once the background has been masked, and before beginning to paint, rubber cement should be applied to mask areas for the small dents in the surface of the fruit. With masking completed, spraying begins, directing the spray and concentration of paint to indicate the volume and mass of the strawberry. When the paint is

The image of the strawberry will be used to illustrate the use of liquid masks.

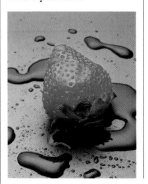

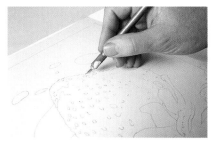

With a self-adhesive mask over the drawing, cut out the outlines of the strawberry.

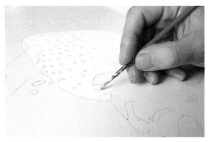

The small dents that give the strawberry its texture should be reserved with a liquid mask.

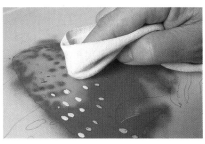

The liquid mask is removed by rubbing with a cotton cloth.

dry, rubber cement areas are rubbed off with a cloth, leaving white. Now do a fast spray of yellow, which slightly warms the red tone and colors the white yellow for the seedy surface.

Background and Details

When the color has dried, remove the liquid mask by rubbing with a rubber cement pick up or a clean, dry cotton cloth.

To further develop the image, mask the shape of the strawberry and unmask the part that corresponds to the leaves, spraying them with green, shading with black. The same operation should be repeated with the puddles and drops of water that surround the strawberry; these are unmasked and sprayed with black, and over that with a slight amount of green, shading around all the perimeter. Once all the spray-

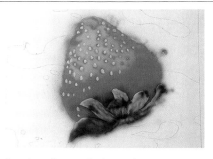

Sprayings of a second color are done, coloring the reserved spaces.

The details of the splashes of water on the leaves are done by hand.

ing has been finished, any touching up that is needed can be done with the point of the paintbrush. The airbrush on its own can give a fine line of between 0.2 and 0.3 mm but controlling such thin lines is very difficult. Gouache and colored pencils are therefore used to add such lines to the work. If, when hand retouches such as these are made, a difference in texture is visible, the area may be sprayed over lightly as long as lines are bold enough to hold. Next, fine spraying with

the airbrush can be done around the puckers in the fruit, with opaque white, to give a convincing appearance of shine. A colored pencil is useful for defining the details of the drops of water. Gouache applied with a fine brush around the edges of the leaves will round off the effect of volume and dimension.

> **MORE ON THE SUBJECT**
>
> • Basic practice **p. 32**
> • Masks **p. 34**

Touching Up Masked Areas

The white spaces created by using a liquid mask will always have to be touched up, with either gouache, colored pencils, or even the airbrush itself. This is because these reserved spaces are otherwise too visible. The edges between the sprayings and white paper or the base color will need more of a transition. For high level, precision results, these hand touch-ups need to be done one by one.

An Indispensable Aid

A liquid mask forms part of an artist's essential material as nearly all the jobs require, at one time or another, the use of this kind of reserved space. It is true that you can find other methods such as small pieces of adhesive paper or by applying white wax, but the former is difficult to handle and the latter is very difficult to eliminate. A liquid mask is quick, handy, clean, and its yellow color (it is also available in other colors) makes it easy to find on white paper or on the base color.

The liquid mask should form part of the airbrush artist's basic material.

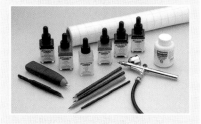

Result of the exercise. Great detail has been achieved thanks to the liquid mask.

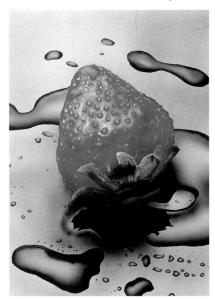

PAINTING A CUBE AND A SPHERE

All objects are made of general, modified geometric forms. The
three-dimensional world can be visually understood as being made
of combinations of curved and angular volumes. For effective visual
representation of observed reality using an airbrush, the artist needs
to master the depiction of these forms. An accurate sense of light and
shade are key for their representation. As a fundamental exercise,
we suggest painting a cube and a sphere.

A Cube

The secret of a convincing representation of a cube using an airbrush is the correct preparation of the masks. A cube seen in perspective requires very simple masking. The order of painting and masking is key, working from upper left to lower right. The mask for a cube is perfectly hexagonal in shape, following the contour of the cube. Start by drawing the cube in perspective on the surface to be painted. Mask the surface and cut into the boundaries of the hexagon as well as into each of the cube's surfaces. Now remove the section of mask that corresponds to the cube's topmost surface. Spray this area lightly, as this surface of the cube is most brightly lit. When color is dry reapply the mask and remove another section, corresponding to another of the cube's facets. Repeat for each of the cube's sides,

The masks to be used are: the outer perimeter of the cube seen in perspective and the three visible sides marked in the diagram with the numbers 1, 2, and 3.

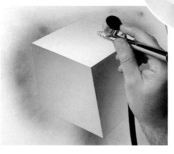

1. Uncovering mask number 1, the upper face of the cube is sprayed working to fade the color to produce shading.

2. Cover area number 1 with the mask again and uncover number 2, carrying out the same operation situating the dark section of the shading next to the light vertex of the previous face.

3. The operation is repeated covering all the faces except number 3, spraying this with a slight fade.

adjusting the intensity of spraying to create fades to represent the cube's tones and shadows. This process is repeated until the volume of the cube is complete. Then the mask is removed. The result will show a three-dimensional effect given by the perspective of the planes and the effects of light and shade. In order to do this exercise it is advisable to use medium-toned shades, diluted with water until a soft tone has been achieved.

Before reaching the final result, steps 2 and 3 should be repeated to intensify the shading of the vertices.

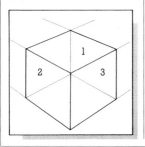

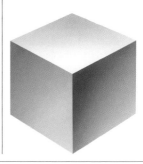

A Sphere

A sphere is a complex volume regarding the configuration of light and shade on its form. It has a continuous surface, smooth and without edges. When airbrushing a sphere, the direction of spraying should always be circular and freehand. This will produce a rhythmic motion of wrist and arm. For the best results three masks should be used. Two of these should be circular: one should be the exact size of the sphere, the other, a little bigger. The third mask should be curved. First, cut out the large circle and lay it on the painting surface. Now apply the first coat of paint with a circular motion. Concentrate the intensity of color around the edges of the sphere. Choose the direction of the light so that its effect may be represented. Once this has been done, the area opposite the light source should be darkened to suggest volume. Fading should be gentle, carried out in a circular movement, following the shape of the sphere. Coverage with paint should be progressive until the desired depth of tone is achieved. Intensity of color can be increased with subsequent layers of shading. Each layer is sprayed with the same circular motion, trying not to stop the airbrush as this produces unwanted concentrations of color.

To paint a sphere, you will have to use three masks. Mask A is to create a general spraying, B to produce internal shading, and C for the shine.

With mask A in place, a general spraying that fades slightly is done to suggest shade.

The next step consists of removing the first mask and replacing it with the smaller circle, saving the first one to be used again. Covering the center of the sphere, slightly fade the most illuminated area, and further darken the shading of the darker area. Immediately after, the center is uncovered and the first mask is reapplied to deepen the area of shade with more paint. Finally, to give a bright shine to the most illuminated area of the sphere, the third mask is applied and the color is toned down by rubbing the eraser over the area exposed through the mask.

Using mask B, the internal area of the zone is accentuated.

Mask C is used to open a partial shine in the upper part of the sphere.

The final result of the work. The shade and shine show a balanced tone.

Shade, Shine, and Masks

Another way to handle a sphere is by using a small oval-shaped mask to produce the contoured shine in the brightest part of the form. This highlight can be further brightened by spraying with white or rubbing out with a soft eraser.

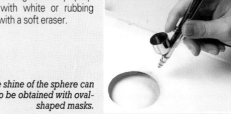

The shine of the sphere can also be obtained with oval-shaped masks.

MORE ON THE SUBJECT
• Basic practice **p. 32**

OTHER GEOMETRICAL SHAPES: A CYLINDER

The distribution of light and shade on the surface and the interior of a cylinder has its own properties. Cylinders are important to understand as they are the general structure for many other forms. Imagine the light source at the upper part of the cylinder; therefore, the darkest tone will appear in the lower portion. The effect reverses itself for the interior of the cylinder, placing dark behind light and light behind dark. The airbrush should be kept in motion similar to the painting of the sphere, working side to side rather than in circular motions. The highlights and accents will be lighter or darker strips that define the shape and texture of the cylinder.

Two Masks

Once the diameter of the cylinder has been decided, the masks have to be made from two basic cutouts: the exterior shape and the interior shape. The configuration the fade will follow is determined by the light and shade needed on the surface to be covered. First the exterior surface should be painted and then the interior surface. After drawing the cylinder and laying a general masking, cut the shape of the exterior surface of the cylinder into the larger mask. Both shapes in the cylinder should be cut in this way so that they may be detached and lifted from the mask after each painting operation. The second surface corresponds to the opening of the cylinder. In order to be able to paint it, you have to remask the first section. Then apply the fading process downward to produce a large, intense area. This will give the impression of a hollow tube. Alternating the two masks, continue the spraying process until you have achieved a solid sense of the cylinder's volume. Using one or more straight masks, you can produce shine and highlights that finish off the impression of volume. With an eraser, using a stencil as a template, you can pull out a glint in the upper part of the exterior to give a metallic effect. The surface of the interior requires similar handling.

Here you may also add some straight white areas and some rubbing out.

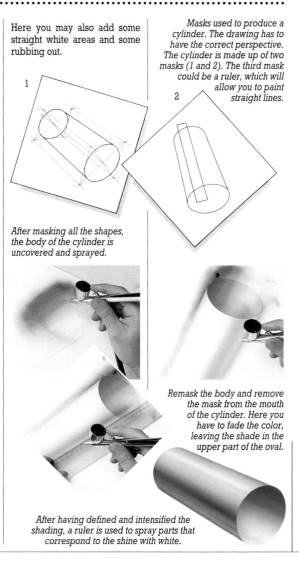

Masks used to produce a cylinder. The drawing has to have the correct perspective. The cylinder is made up of two masks (1 and 2). The third mask could be a ruler, which will allow you to paint straight lines.

1

2

After masking all the shapes, the body of the cylinder is uncovered and sprayed.

Remask the body and remove the mask from the mouth of the cylinder. Here you have to fade the color, leaving the shade in the upper part of the oval.

After having defined and intensified the shading, a ruler is used to spray parts that correspond to the shine with white.

Painting a Cube and a Sphere
Other Geometrical Shapes: A Cylinder
Summary of the Use of Masks

43

Composing Geometrical Figures

Building on the procedures and techniques for cubes, spheres, and cylinders, the artist can produce a composition of simple geometrical forms. The task this composition entails is the depiction of a group of forms illuminated and shaded by the effects of one light source, affecting the forms in a similar way. The masking and painting procedure for this exercise must be methodical. The forms can be painted in one, or in different colors. The first step consists of making a careful sketch. The volumes need to be placed in a convincing way so that each one of the shapes occupies a coherent place in the composition. Then a general mask should be laid down. After drawing the outlines of the composition onto the mask, each area should be cut out. The first shape should then be uncovered and sprayed, the rest of the operation continuing in the same way as in the previous exercises. One shape is done at a time, then remasked so that you can paint the next shape, the process continuing until all the shapes have been painted. The final step consists of applying shine and glints, creating cast shadows, and adjusting tones to give uniformity to the group.

Once all the volumes have been painted, the relationship of light and shade needs to be adjusted.

Masks for Cones

Two masks are enough to paint the cone: one fixed and the other moveable (a ruler). The fixed mask is a contour of a cone in perspective. The cone consists of only one curved face, painted in cast light and shadow from the vertex to the base.

A diagram of the masks needed to produce the cone in the exercise on these pages.

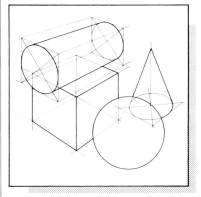

This is the set of masks needed to carry out a composition of geometrical shapes. The shapes can be painted individually using the mask procedure demonstrated previously. The cone can be painted using a single, fixed mask.

Each of the shapes must be worked separately, piece by piece, until the composition is completed.

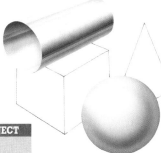

MORE ON THE SUBJECT
- Basic practice **p. 32**
- Painting a cube and a sphere **p.40**

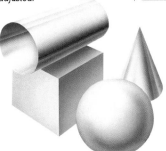

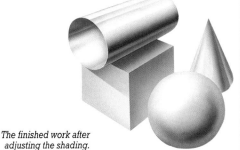

The finished work after adjusting the shading.

SUMMARY OF THE USE OF MASKS

The preceding series of exercises for the use of masks offers a wide range of possibility, requiring careful, methodical steps. Next, we will apply the principles worked with, to paint a subject more complex, yet based on simple geometric forms.

A Summing-up Exercise

This exercise involves the representation of a substantial still life. Its execution requires the use of both fixed and moveable masks, airbrush painting of geometric volumes, and the representation of shade and shine. It includes the application of finishing techniques to produce a polished result. Each of the objects follows basic geometrical shapes: spheres, cubes, rectangles, and cylinders. Again, and as a general guideline, remember that the execution of any kind of airbrush illustration will always involve continually moving the masks from one place to another, limiting the area of spray so that the adjoining areas are not affected. Basically the same technique is applied whether forms are simple or complex. In the exercise presented here, the procedures will be basically the same because the shapes of the objects in this composition vary very little from those forms we have already done. In any kind of work with an airbrush, knowing how to break down a subject into its basic planes, forms, and essential surfaces, and the procedure for masking combinations, makes up the core of strong technique.

Preliminaries

First, the drawing on paper must be extremely precise, finely drawn, and without any ambiguities as to the location of the outlines. It must have clear indications of the limits of areas of light and shade. The margins of the paper should be masked with tape so that the borders of the final image will be perfectly defined. Once this is done, all of the illustration must be masked and the outlines of the objects and color areas must be cut out carefully for clear definition and maximum precision.

Background

Once the limits of the subject have been cut out, the masking area that corresponds to the background is removed, leaving the subject covered. This background is painted with a fade of grayish blue, starting from the top left-hand side of the illustration. Once this background color has

Protecting the subject with masking; start by spraying the background.

The spherical lampshade should be handled in the same way as a sphere, by spraying in a circular motion.

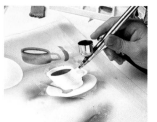

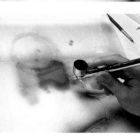

The red and orange colors of the base of the lamp are sprayed while the rest of the picture is covered by the masks.

The cylindrical part of the coffee cup is sprayed with the airbrush as if you were representing a section of a cylinder.

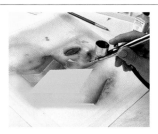

The book should be completely uncovered when spraying with the airbrush, painting the outlines and shading freehand.

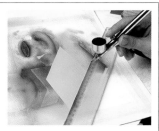

The lateral edges of the book are painted by masking with a ruler.

been painted, we can begin on the table area. First a ruler is placed in position to reserve the upper limit of the table. Starting from this point, the table is painted in a fade with an orange for the upper part, leaving the lower part almost completely white.

Elements

In order to paint each one of the elements, you have to unmask them, leaving the adjacent areas protected. In this way you can paint, one by one, all the elements of the composition. After having painted each element, it is immediately masked to continue with the next one. In the area of the lamp, the part painted in orange is unmasked and its two visible faces are painted with the airbrush, first with a general spraying to cover both faces. It is then given a veiled gray color on the shaded face, shaping its corners with light fading

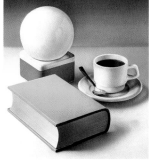

After the finishing touches, this is how the illustration looks. The characteristics of the forms are individual but their basis is geometrical.

to indicate the curved forms at the angles. In order to paint the spherical lampshade, the base should first be masked. Then spray the volume of the shade as if you were dealing with any sphere, shading just enough to bring out its volume.

MORE ON THE SUBJECT

• Other geometrical shapes: A cylinder **p. 42**

A Look at the Result

When working with self-adhesive masks, you are unable to see all the finished work until the very end. While working, there are always areas that are partially hidden from view. This means thinking the sequence of work through ahead of time, knowing the order in which the color must be applied. Another option is to remove all the masks at certain points, make sure things are proceeding as planned, then to replace the masks. This makes the process slower but assures correct execution.

Only when you have finished the work sequence can you see the piece in full view. Up until then, the masks have hidden a large part of the illustration.

A Coffee Cup and a Book

The first step in dealing with the coffee cup consists of removing the cutout part of the mask that covers the surface of the coffee and painting it. Continue the painting process by covering this area again and going on working with the rest of the coffee cup, repeating the process of unmasking, spraying, and remasking for the saucer. The use of moveable masks is helpful for this process, too. Use cutouts for each area to outline precisely the more subtle volumes and edges of each shape. These can be cut out of board to the correct size. The book can be painted as if painting a cube; the faces are almost completely flat and you work by lifting off the masks for each face, each in its turn.

Finishing Off

Remove all the masks and, with a rubber cement pick up, rub out any residual glue from the adhesive mask. As finishing-off details, you can highlight the shine of the globe of the lamp, the surface of the coffee, and the edges of the cup, saucer, and book.

TRANSFERRING A PHOTOGRAPHIC IMAGE

The majority of projects done in the medium of airbrush start with a photographic image. The realistic technique that can be achieved with airbrush uses photography as its model. Without having a photograph to look at, it would be impossible to reproduce the varied effects of shine, texture, and luminosity possible with airbrush techniques. The work can be based on a combination of various photographic images or the reproduction of only one. In both cases it is necessary to do a transfer of the photo onto the support in order to make the masks.

Methods

It is important that the artist has a clear idea of the way the finished piece will depart from photographic images before starting. Poses, colors, placement, shadows, and even shapes and forms may be varied and developed, though based on photographic references. Once the image has been chosen, the processes used to transfer it to the support will vary from artist to artist, and be based on personal technique.

Projection

A common practice consists of projecting an image onto a support or mask with a slide projector. The slide is placed in the projector, then is projected onto the paper, which is fixed to a board on the easel or fastened to a studio wall. The projector should be situated at a height that is comfortable to

To make the transfer of the image to a drawing easier, slides and a slide projector can be used.

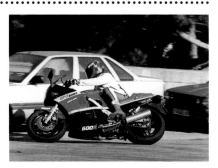

work with. The size of the projection will be determined by the distance at which the projector is placed; by varying this distance it is possible to adjust the image to the desired size and format. It is very important that the projector's location is fixed so that when it is switched off it will not be moved before switching on again. It is also essential that

the paper or mask is completely flat and fixed so that it does not move at all while you are drawing. The image must be sharply in focus so that you can draw each of the details with maximum precision. The drawing should be a line drawing in order to be able to determine the outlines of the mask to be cut out. Lines should indicate all the details of the

A slide projector allows you to enlarge the photograph considerably and aids with the drawing of the initial sketch onto the paper.

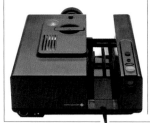

Light Tables

A light table consists of a box that contains fluorescent tubes and is covered by either glass or transparent plastic. It is used to view slides and to make typographic layouts. It is a good tool for doing detailed tracing because it enhances the transparency of the tracing paper and even much thicker papers, and allows you to see the details of the photograph. It is very useful when the work must be the same size as the original photograph.

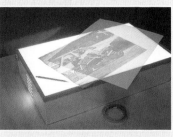

A light table is an excellent tool for slide viewing and for tracing small and medium-sized photographs.

MORE ON THE SUBJECT

• The studio, furniture, and accessories **p. 30**

image, as well as the limits of the main areas of light and shade.

Transferring with a Scaling Grid

This system consists of dividing the photograph into squares and then reproducing this image, enlarged, on the paper or the mask. The reference point and framing between one square and another allows you to draw the outlines and details of the image to scale while maintaining the proportions of the original image. The smaller the squares are drawn, the more precision will be achieved because there will be more

Once the photograph has been projected you can draw over it, following its outlines to achieve an exact tracing of the original image.

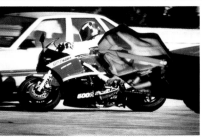

points of reference for situating the lines of the drawing. To multiply the reference points, you can draw diagonal lines that cut the vertices of the squares from right to left and from left to right. Though this is a labor-intensive method, it is a good tool for the accurate reproduction of a drawing. It is most practical to do a grid drawing on the mask, rather than the actual support surface, as the erasure of lines of reference will damage the drawing.

Tracing

If you are working to size, you can simply trace the photograph. A grid can be drawn on the tracing paper and used for cross-referencing with the photo. Once you have finished the tracing, darken its lines on the back with a soft graphite pencil. Afterwards, place the tracing on the paper and go over the lines with a fine hard pencil; the drawing will be transferred onto the paper.

The transfer of the image with a scaling grid consists of squaring off the original image and the paper and then transferring one to the other following the guidelines.

Once you have traced the photograph onto the tracing paper, you can simply transfer the drawing onto paper by rubbing over the back with a pencil.

Go over the drawing using a pencil with a fine point.

The drawing will be transferred onto the paper without having to use a scaling grid.

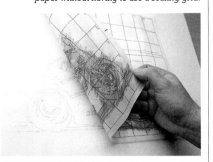

MATERIAL

Airbrush is one of the best mediums to reproduce, in a photo-realistic way, the weight, surfaces, and textures of objects. While it is true that the flat colors the airbrush uses in some ways cannot produce the same rich, three-dimensional effects as oil or acrylic, airbrush can imitate glossy, shiny, metallic, or glass surfaces like no other method.

Color Consistency

All painting methods have their own characteristics. Even watercolors, which are the most delicate of all, have a particular physical appearance, a soft, freehand, washy quality unique to itself. The airbrush, on the other hand, has a much more commercial look. Its flat, perfect surface, made up of tiny particles of paint, shows no evidence of the hand or paintbrush. This gives it a mechanical coolness as opposed to the more expressive qualities of other painting methods. Yet the airbrush is highly adaptable for purposes of representing any material. Airbrush, unlike oil, acrylic, and watercolor, has a highly slick finish particularly suited to the representation of manufactured surfaces, such as glass, metal,

An ideal subject for the airbrush artist: polished and shiny surfaces executed with impeccable realism.

plastic, and anything else machine tooled and shiny. Airbrush, like the materials it is so suited to reproducing, is a medium of slick, polished precision.

MORE ON THE SUBJECT

• Transparency **p. 62**

Common Subjects

Common subjects represented by airbrush are objects, the qualities of which demand clear definition. Though the majority of the work done with airbrush is oriented toward advertising and illustration, areas such as industry and

The shine and textures of this still life are taken to the highest degree of finish.

The representation of the material and texture in this image make it look almost real.

communications, which need to convey clarity of message and the polished depiction of subjects, frequently employ its use. Light is a very important factor in airbrush work. Thanks to the subtle fading of color that the airbrush affords, it is easy to recreate the effect of light moving across a smooth surface, giving progressive shade, reflections, shine, and edges that are perfectly defined.

The representation of textures can be developed beyond realism, making for strong visual impact.

Transparency

The quality of transparency is one that is difficult to represent with visual accuracy using oils, acrylics, or watercolors. The density of these mediums often works against such clear representation. The fact that the airbrush paints with air and tiny paint particles, giving the paint a consistency and texture that parallel photography, enables this medium to exactly produce the illusion of glass and crystal. The combination of sprayed opaque color and masking techniques unique to airbrush give it the ability to create effects of impeccable realism that cannot be duplicated by any other medium.

Shine and Flashes

As with transparency, shine and flashes of burnished and chromium-plated objects are relatively easy to obtain working with an airbrush. These flashes come from the photographic sense of capturing an instant of light. Using a naturalistic painting, for instance in oils, such photo-realistic flashes are barely possible. The airbrush, however, can catch, as no other medium can, a perfectly photographic look. For this reason the great professionals of this medium often choose subjects that involve spectacular luminous effects.

Cinematic Effects

In addition to so closely imitating photographic effects, airbrush can reproduce cinematic effects, such as well-colored light in motion, special effects of light and shadow, blurring as a result of speed, etc. In the accompanying illustration, the colored illumination radiating from the letters reproduces effects typical to television or cinema. These effects can not be achieved with any other pictorial medium.

Advertising illustration based on the effect of cinematic light.

THEMATIC EXERCISE (I)

The best way to demonstrate the processes and techniques of the airbrush is by doing practical exercises that bring together examples of the principal methods of working and the most commonly used procedures. From here on, you will find work set out that is not too complex and that can be done by applying the techniques described.

A Rose

This exercise is particularly suitable for practicing the freehand use of an airbrush. The background area of this composition and a large part of the flower will be done freehand. Because the rose calls for a soft, transparent look, liquid watercolors, which are transparent, will be used as the painting medium.

In this and in most work carried out with an airbrush, it is a good idea to do some preliminary studies and exercises with the aim of making sure that the final result will be of high quality. It is important to remember the necessity of working from light to dark. By superimposing layers of sprayings, the color and tone can be gradually intensified. It is useful to begin by spraying a fine coat of color. Continue applying successive coats of the same tone, creating areas that are darker. The color should be done in fades, spraying from different distances to increase effects. Exploring a variety of

Mask drawn of the rose. The contours and outlines are carefully observed, defining each area simply and clearly.

spraying effects will help you to determine which are most suitable. The more you allow

the white of the paper to show through the coat of paint, the lighter the color will be. The luminosity of the result will depend on this factor.

The Mask and First Steps

Begin with a precise pencil drawing of the outlines of the flower, drawn on a self-adhesive mask. As you draw, determine the placement, shape, and size of the most important shiny areas to include these as areas for masking. After having taped the paper on four sides to a board support, the mask is placed on the paper and the

Using a raised mask to completely cover the rose, the background is painted green.

Protect the background once more and uncover the flower. Reserve blank spaces in the center for the high whites—the shine of the petals.

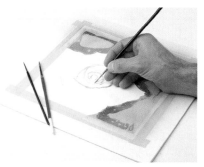

Using a shade of pink, the tone of the base of the flower is applied, blocking in an initial sense of volume.

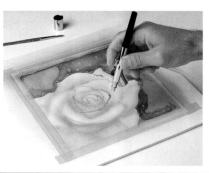

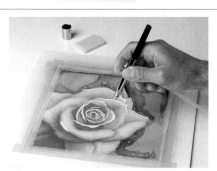

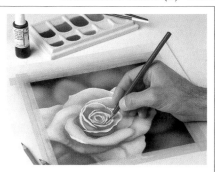

The liquid mask is eliminated with an eraser. By using darker tones and alternating the masks of the petals, shapes contrasting the shade are reinforced.

The whites, which are too hard-edged, must be blended in with the central shine. Colored pencils are used to provide a transition.

general outline of the flower is cut out. The background is left uncovered. Only the area of the rose itself is masked. First, a light spraying of green should be done. Then, in order to create a covering of diverse tones, lighter and darker areas will be created by continued sprayings. You can spray the area again to soften and produce a slightly unfocused effect, which will suggest a background of leaves. The green has to be dark enough to strongly contrast with the rose color of the flower.

Masking the Background

Once the background has been painted, it is covered up with mask material, while the flower is now uncovered. In the center, around the edges of the most central petals, areas of shine should be reserved by covering them with light brushstrokes of liquid rubber. That way the spraying of color will not affect the white of the paper in these areas. Then, a general spraying can be applied that will block in the flower's color.

Masks in Parts

To obtain the internal outlines of the petals you will need to cut out successive fragments

of the masking. Follow the lines of the original drawing and place these small pieces of mask one after the other on the flower. Each one of these small masks allows you to outline the outer edges of the petals. Continue this process until you have modeled all the petals in a convincing way, using a graduation of tones for light and shade. The last step consists of removing the liquid rubber to expose the white of the paper, which will now function as the shine. To lessen the contrast between this white and the rest of the painted area, you can highlight the outlines with the aid of a red colored pencil.

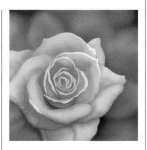

The finished result; strong contrast between green and pink make for a compelling composition. Notice the velvety texture of the paint.

MORE ON THE SUBJECT

• Illustrated examples of masking **p. 36**

Outlines and Masking

Masking allows an easy demarcation of the outlines, as the mask itself stops the color from extending and creates a perfectly cut border. In keeping with the combination of the masks, outlines are overlapped and superimposed, producing a variety of effects. Before removing any of the masks you must be sure that you have finished working on the area and that the masks are no longer needed for retouching.

Masking enables you to work freely, without marring areas of shapes that remain perfectly protected.

THEMATIC EXERCISE (II)

The second of our thematic exercises is somewhat more complicated than the previous one. Its complexity has to do with the meticulous finish required. But all the work simply builds upon the techniques and procedures we've already used. The finish of this piece is almost photographic and, again, could not be achieved with any other medium. It is an image that might be used in advertising and requires high-tech attention to detail and shading.

Photographic Quality

Because of its particular characteristics, the airbrush enables you to obtain finishes that are surprisingly similar to those obtained in color photography. It was first employed, after all, for retouching photographs. The air distribution causes the particles of paint to blend gently together on the surface, creating fades that are perfectly continuous, without being marred by brushstrokes. The luminosity typical of color photography is also created by the airbrush. Working with ink, liquid watercolors, or any other transparent medium, it is quite possible to achieve effects of light and shade equal to those seen in photography. Subtle color fading combined with pencil finishing touches produce results that duplicate the precision of photography and even surpass it.

The unlikely juxtaposition of a fist against a seascape might well be used as an advertising image. The first step toward achieving a realistic effect, reproducing the anatomical structure of the hand and the illusion of skin and skin tones, is to carefully study the photo and determine the stages necessary for masking and spraying.

First Masking

Once the image has been drawn to the required size on the mask, place it on the paper and cut out the outline of the fist. Then cut out the shapes of the reflections on the water

Using a photographic montage as a model, a mask is made of the illustration delineating the limits of the main shadow areas.

within the larger mask. The halo of sun that surrounds the central image needs a raised mask to achieve the blending

Using a circular mask made up of two concentric circles, spray the outer circle that surrounds the image.

Using the smaller circle, spray the inner circle, keeping it slightly above the support.

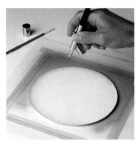

of the edges of both the inner and outer areas of the halo.

This mask, two concentric circles, must be made of stiff board so that it is easy to handle and won't bend, distorting the edges. The central part of the cutout, its inner circle, will serve as a mask for blurring the outer halo.

These raised masks must be lifted slightly off the support. To do this, place a ruler, a T-square, or other flat object under the mask. Then, with the mask of the smaller circle in place, spray with the color of your choice until a uniform halo is achieved. With the circular mask in place, slightly raised, spray first the blue of the sky and then the color of the halo, taking care to blend the shades well.

Covering all of the image except the reflections on the sea, spray to block in its color.

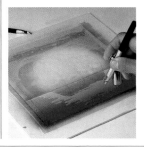

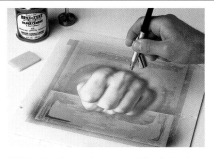

With the hand unmasked, spray with a flesh color to obtain the first areas of light and shade.

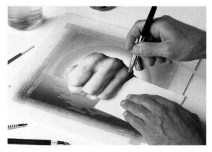

Using a darker color, define the contrasts and outlines of the fingers.

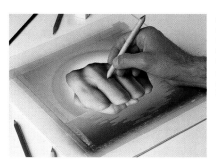

Small details like hairs and wrinkles should be done with a pencil, blending in the strokes.

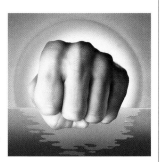

The final illustration.

The Central Image

Once the outer area of the image has been painted, place a mask over the line of the horizon, at the same time keeping the mask of the fist and reflections in place, and spray the lower area, the sea, blue.

The next step is to paint the inner area of the fist. To do this, cover it with the outer mask, leaving the inner area of the hand exposed. Working freehand, spray with a very pale base color, carefully intensifying areas to form the light and shade of the fingers and knuckles.

Outlines and Masking

To produce the outlines and forms of the fingers and knuck-les, cut out partial masks following the outlines for these areas. Repeat the procedure to blend the light and shade that mark and give volume to each of the fingers and knuckles. It is important to spray very carefully, deepening the color gradually to produce the illu-sion of the hand. Look closely at the photographic reference as you work. To finish, define the small areas of shine, shadows, furrows, and wrinkles, using colored pencils. Work lightly so as not to overempha-size them. To blend in the pencil strokes, use a stump.

The Importance of Colored Pencils

Colored pencils are sometimes irreplaceable when it comes to retouching or outlining details. They are very versatile and some types can be moistened with water to eliminate strokes altogether. This quality makes them particularly suitable to complement work done with an airbrush.

Graphite and colored pencils are an indispensable complement to most work done with an airbrush.

MORE ON THE SUBJECT

• Illustrated examples of masking **p. 36**
• Thematic exercise (I) **p. 50**

FREEHAND AIRBRUSHING (I)

The theme of diaphanous cloud effects is without a doubt one of the most exciting exercises for the airbrush artist. This type of subject requires great subtlety and the airbrush is well suited to achieve it. Airbrush uniquely conveys a realistic sense of clouds, as the paint, driven by the air spray, assumes a similar vaporous form. In this exercise, the cloud effects are achieved without the aid of masks, working freehand.

The Airbrush for Pictorial Works

A painting or illustration done in the medium of airbrush can be considered and approached in the same way one would any other more conventional medium, such as oil or watercolor, using the airbrush in the same way one would a brush. A photo of clouds will be used as a model for the next painting. In freehand airbrush, the original drawing should not have definite lines but rather consist of a clear and well-proportioned sketch. It does not need the precise definition of areas that a piece being prepared for masking would. Before starting to spray the color one must think through the effects one is aiming for: dark blue sky contrasting with the whiteness of the clouds, subtle blending of whites to give volume, and finally, erasing to highlight the whites.

Fuzzy Outlines

As though using a brush, spray the outlines of the clouds with deep blue. The airbrush will leave fuzzy outlines, which works to the advantage of the subject matter of clouds. These strokes define cloud shapes without using stencils or masking of any kind. The blue used for the sky should be mixed with a little white to make it more opaque and solid. That will add to the realism and

The photograph. There is no need for tracing as the painting is carried out freehand.

The illustration after the first sprayings; intense color with, as yet, no depth.

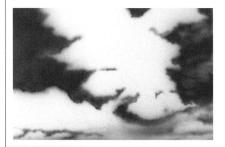

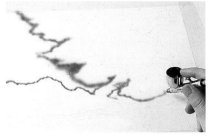

Once the outline of the clouds is drawn, start spraying, outlining the edges with blue.

With the airbrush loaded with gray, the whites of the clouds are shaded and blended.

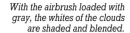

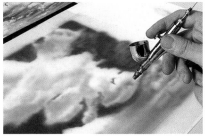

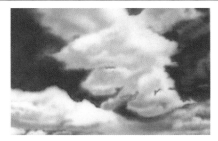

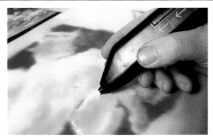

The illustration after shading the clouds. Just a few sprays of gray create the three-dimensional effect.

The electric eraser is very useful for emphasizing light along the upper edges of the clouds.

You can also use an ordinary eraser to blend shades and add volume to the body of the clouds.

The finished picture. This simple freehand piece contains more depth of color and impact than the original.

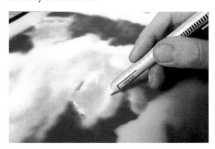

overall impact. The colors can be mixed in the paint cup, stirring the contents with a brush.

Shading of Clouds

The color of the clouds is taken from the white of the paper. They now have to be shaded in order to give the impression of volume. To effect this, fill the airbrush with pale gray to which you have added a few drops of blue to harmonize the color with the sky. Use the original photograph as a guide. You can even simplify and clarify the play of light and shade to achieve a more pictorial effect. To be sure the shadows are soft, before starting to paint, check the flow of color on a piece of scrap paper.

Erasing

The grays have created a general shading that has covered most of the whites. To pull out the contrast between clouds, use the electric eraser along the upper edges of some of them. The whites in the inner shaded areas can be brightened and blended with an ordinary eraser.

Controlling the Spray

Working freehand is not difficult when covering large areas, but if there are lines to draw that require precision and a steady hand, it is advisable to hold the airbrush with both hands.

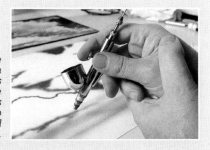

Holding the airbrush with both hands ensures the steadiness necessary to control spraying.

MORE ON THE SUBJECT
- Masks **p. 34**
- Illustrated examples of masking **p. 36**
- Freehand airbrushing (II) **p. 56**

FREEHAND AIRBRUSHING (II)

Canvas is not usually used when painting with an airbrush, but it can be used for freehand work that doesn't require a great deal of subtlety and meticulous effects. A coarsely woven canvas texture won't detract from a more expressive work and may even enhance it. Canvas of finer weaves should be used for airbrush, and it must be stretched and primed as it would be for painting with acrylics.

Method and Color

This work will be done freehand. The only masks used will be a ruler and rubber cement. The material must be stretched or fixed to the work surface with masking tape, and must be completely free of creases. If taped it may be dampened with a sponge after tape is in place so that it dries taut and completely flat. Next, using blue and black airbrush acrylics, begin to develop the painting freehand. These colors should be diluted with airbrush acrylic extender, rather than water, available at an art supply store. Acrylic colors are more dense than watercolors and inks and can block the nozzle. In that case the needle will need to be moved to unblock the nozzle. When working with acrylics it is easier to work with the airbrush handle removed for easy access to the needle.

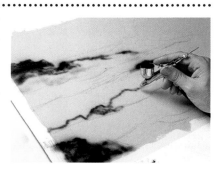

Having completed a superficial sketch on the background, go over the lines with a very dark blue.

use a ruler to draw a completely straight transition of shade, but for the most part, as in the piece pictured here, this more impressionistic style of work can be completed freehand. The rocks are more clearly defined areas of blue-black. It is their contrast that produces the spatial effects of foam and waves. The darkest part of the waves comes from bright blue, which is applied leaving clear large areas that form the foamy crests. After finishing the general painting of the rocks and waves, paint the areas of high whites and shine. This is done by applying small touches of white acrylic paint

with a brush. These are elongated spots of paint that suggest the shine on the surface of the water.

To achieve the effect of shine on the foam, hold the airbrush at a distance and spray with white. This will create the effect of diffuse brightness characteristic of foam. In this phase it is important to make any necessary adjustments of shades and colors, to even out

MORE ON THE SUBJECT
- Thematic exercise (I) **p. 50**
- Thematic exercise (II) **p. 52**
- Freehand airbrushing (I) **p. 54**

White and Shine

At some point in a freehand piece it may be necessary to

To differentiate between areas you can use a ruler as a mask.

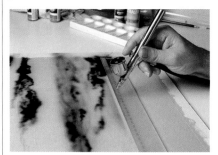

The chromatic base of the waves and rocks is done freehand without using a mask.

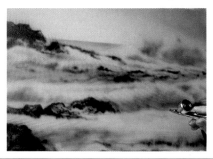

Base Colors

Before using the airbrush on canvas it is important to ensure that it is prepared for acrylic paints. To ensure that the color will adhere properly, it is always a good idea to first apply a coat of acrylic with a paintbrush, to give a smooth base for airbrushing. As in this case, this base can be one of the colors of the composition.

The cloth should be prepared for acrylics, but it is always advisable to apply another layer to ensure that colors will stick.

transitions for the contrasts, and to add any other necessary finishing touches.

Obtaining Uniform Shine

At this point it is necessary to slightly darken the upper part of the sky in order to prevent it from appearing completely flat. Next, all white brushstrokes that represent shine on the water must be covered by gently spraying with white to unify and blend them into the surface. Otherwise the spots of paint will appear discontinuous from the waves. Once all the areas of shine have been unified, they read dramatically as light, a dazzling effect that can only be achieved with airbrushing.

The open weave of the cloth is no obstacle to achieving smooth spraying and delicate blending of color. The grain is visible from a certain distance but this does not spoil the overall effect.

The shine on the surface of the sea is achieved by using a white gouache and a paintbrush.

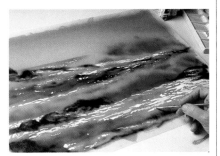

A finger makes a good mask to protect small areas during spraying.

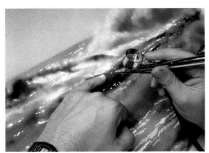

The result of spraying the waves with opaque white to highlight areas of brightness.

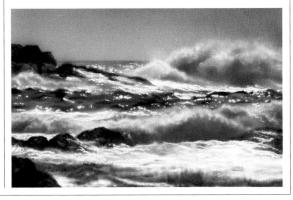

MASKING WITH ABSORBENT COTTON, COTTON BATTING, OR COTTON FIBER

Masking with absorbent cotton, cotton batting, or raw cotton fiber is a simple way to achieve cloud effects. The illusions created using this method are surprising in their realism. This method is simple and effective when learning to use an airbrush and when working on classical pictorial landscape themes. The rest of the landscape involves nothing more complicated than masking the large almost flat areas of color that make up the scene.

Approach

Light is the main feature in this picture. This sort of stark, dramatic light is ideal for the airbrush, as it does not require too much fine detail of color and texture. The dark of the mountain combines with its reflection in the waters of the lake to make a strong composition. The sky and its reflection complete and support the effect. The sky is made up of green-blue and ultramarine

MORE ON THE SUBJECT
• Masks p. 34

blue. The distant mountains and their reflection on the water are blue-gray. The strong shape of the dominant mountains are blue-black.

Only the areas for the mountains and the edges of the lake are masked. The rest of the scene can easily be carried out freehand.

Reserving and Masking with Cotton Fiber

First mask the brightest whites with rubber cement to avoid using too many masks. Next, stick on a few pieces of

cotton fiber, also with rubber cement, which is easily removed once it's dry. Shape the cotton into cloud shapes with your fingers. Once the cotton is in place, and leaving the sky area uncovered, spray it with blue, taking care to intensify the color in the upper area of the picture. When the cotton is removed, the cloud shapes that remain will be surprisingly realistic.

Working with Masks

Using the same blue as the sky, remove the mask and spray the water. This time the

This is the first stage of the picture, when the outlines of the masks are drawn.

Fasten pieces of cotton fiber with rubber cement to form the areas of cloud. Mask the brightest areas of the composition with liquid rubber.

Spray the water area blue, shading areas to create the effect of ripples on the surface.

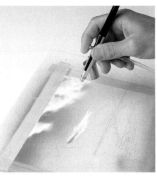

Once you have removed the cotton fiber, add a delicate white halo to the white cloud areas.

The Poster Effect

The contrast of tones obtained with the airbrush and the juxtaposition of simple, graphic silhouette-like images is typical of poster art. The airbrush is a highly effective means for achieving this type of strong, eye-catching composition.

This black and white poster of Charlie Chaplin is achieved by setting light and dark areas against each other, and using fading to soften the contrasts.

same blue-black, having first removed the mask from that area. The spraying of these areas is flat and even. Areas of sparkle and shine have first been protected with rubber cement or masking fluid. Now the liquid rubber mask can be removed with a razor blade,

rather than a rubber cement pick up, which doesn't work well on paint. Scrape the rubber off very carefully to avoid damaging the surface of the paper. To complete the exercise, apply touches of gouache with a brush to highlight the distant shiny areas on the water.

After masking the sky and lake, spray the dark mountain areas. The glint of sunlight and its reflection are first covered with rubber cement.

Without using masks, spray very gently around the areas of sparkle to create a halo effect.

color should not be uniform. Spray some areas darker than others to suggest ripples on the surface of the water. Spray more slowly in some areas to apply more color. Use this technique to cover the lower half of the picture, intensifying at the bottom edge, which is the foreground. The rest of the water is highlighted using the same method as for the sky.

Shade and Shine

The shadows of the mountains and their reflections on the lake are applied using the

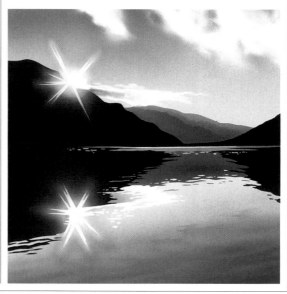

The strength of the finished work is in the highlights and the contrast between dark and light areas. The effect is one of a landscape dotted with points of light from a bright, luminescent sunset.

LUMINOUS EFFECTS

The following exercises illustrate some pictorial uses of the airbrush.
The chromatic sensation of a sunset can be shown to maximum effect
with an airbrush. These effects can be achieved freehand and you
only need to use very simple stencils to mask specific areas of
the composition.

Red Over Yellow

To reproduce this spectacular sunset, start with a quick sketch that shows the position and size of the elements of the scene: the height of the horizon and the rough outline of the clouds. Then you can start work.

The only mask you need is a circle to protect the sun once to reserve the white of the paper while spraying the surrounding area yellow, then again before spraying with the burnt red of the cloud effect. Make the mask using a cutting compass or an ordinary compass to draw a circle and then cut it out

MORE ON THE SUBJECT

• Masks **p. 34**
• Illustrated examples of masking **p. 36**

with a craft knife. First spray the sun with yellow over a wide area that extends to the horizon. This layer shouldn't be too thick, just enough for it to show through the red. Immediately after, cover the sun with the mask and spray with red. This spray should spread into the yellow area; do this by spraying horizontally to imitate the radiations of the atmosphere at sunset.

The Land and the Horizon

Once you have painted the sky, define the horizon with a moveable mask (a piece of paper that's been cut or ripped will do) to cover the area of

Spray over the yellow with red, leaving areas where the yellow shows through.

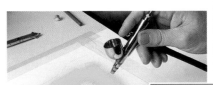

Having sprayed the clouds freehand and retouched them with a red colored pencil, spray the land with blues and blacks using the reserving technique, and the picture is complete.

Start with a light, rough sketch, then spray the sky yellow while keeping the circle of the sun covered with a mask.

On removing the mask the sun appears completely white. On spraying again the yellow of the sun appears much brighter.

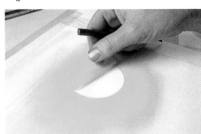

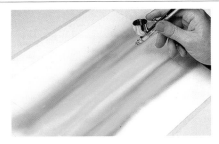

To paint the second scene, begin with a sky made up of horizontal bands of color.

Finish off the bands with violet. On this chromatic background spray the clouds in dark colors.

sky. The mask should be raised a little off the paper to give a slightly fuzzy outline as though blurred by the atmosphere. Although the red paint has overlapped the horizon, the dark blue used to paint it will cover the red and give definition. Repeat the process with the outline of the nearest mountains but place the mask, again a piece of paper, flat on the support. The trees can be painted green with a paintbrush. The shading of the clouds over the sun is best done with colored pencils.

All Freehand

This next sunset scene, very similar in tone to the previous one, can be done using the same colors and very simple masking. The appearance of atmosphere and light can be achieved by spraying horizontal, superimposed layers of differing colors and intensities of spray. First spray faded bands of yellow to serve as a chromatic base for the sky.

Over the yellow spray horizontal bands of orange-red. Vary the distance from the paper so as not to completely cover the yellow. Spray the upper part with violet, blending it into the orange-red. This gives the illusion of the spectacular colors of a sunset. To reinforce the theatrical effect, spray with brown over the base

color for bands of cloud. These bands should become thinner as they near the horizon.

The Last Mask

The last step consists of masking the whole picture except for

The trees are drawn with a fine felt-tip pen. The land is sprayed after covering the horizon with a moveable mask.

a piece at the bottom, the silhouette of the land, which should be left exposed. Spray this exposed area with a very dark color to shade the land mass. Then remove the mask. Finish the composition by drawing in the trees with a fine felt-tip pen.

The Cutting Compass

In the first exercise on these pages we used a circular mask to reserve the sun area. It was cut with a cutting compass. This compass has a blade instead of a lead and cuts the mask instead of drawing it. You can use a craft knife but the cutting compass gives a more perfect circle.

The cutting compass makes cutting circular masks much easier.

PROCEDURES FOR THEMES

TRANSPARENCY

Transparency effects are some of the most interesting illusions an airbrush will create. The subtle nature of the airy texture, made up of fine particles of spray, produces surprisingly realistic illusions of glass, its shine, and reflections. The focus of this exercise is on creating the illusion of the transparency of glass.

The Nature of the Subject

One of the areas considered most difficult in traditional painting is depicting glass and transparency in general. Using an airbrush makes it is easier to achieve these effects. The technique of conventional painting, involving the application of colors in thinner or thicker coats, makes it difficult to depict polished and shiny transparent surfaces with all their reflective and translucent nuances.

It is the unique property of the airbrush, and its air-driven dispersal of paint, that gives it the capacity to create the sort of polished effects that quite naturally represent glass, crystal, or burnished metals. Therefore, transparency poses no technical problem when working with an airbrush; it does of course require meticulous attention to detail when combining masks and playing with intensity of color.

The Background

Follow the usual procedure prior to doing the exercise: trace the photograph, transfer the picture onto your paper with fine, precise strokes, and put the mask in place. To airbrush the background, cut out the mask and remove all of it except the parts correspond-ing to the pitcher and the bottle. The background consists of a fade of gray that goes from dark to pale and from top to bottom, leaving the bottom of the paper practically white. Once this is done, and before removing the masks of the objects, spray their bases to represent the shadows cast by the bottle and the pitcher.

This is how the initial drawing should look, showing the borders of the shine and the reflection on the glass.

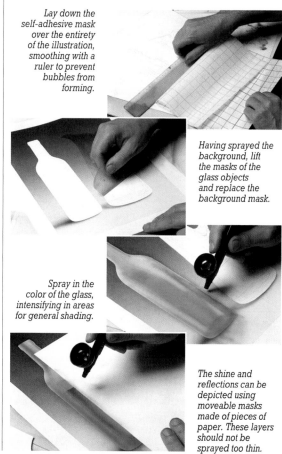

Lay down the self-adhesive mask over the entirety of the illustration, smoothing with a ruler to prevent bubbles from forming.

Having sprayed the background, lift the masks of the glass objects and replace the background mask.

Spray in the color of the glass, intensifying in areas for general shading.

The shine and reflections can be depicted using moveable masks made of pieces of paper. These layers should not be sprayed too thin.

The Bottle

Once again, mask the paper completely, except the part that corresponds to the shape of the bottle. This is now ready to be painted. It is advisable to work out beforehand where the light and shadow will fall, which areas will be lighter and which darker, taking into account the shape and intensity of the areas of shine and reflection. The painting of the bottle starts with a gentle, general spraying, concentrating the spray on those areas that need to be a brighter green. It is important not to go over into the lighter areas reserved for shine. Once this is done, replace the mask of the bottle and cut out the areas that correspond to the darker shades, lifting them off and leaving the rest of the mask in place. When you have successfully depicted the shadows, lift off the mask of the bottle and, with the help of moveable masks cut for the purpose, finish off the reflections.

The Pitcher

The airbrushing of the pitcher follows, more or less,

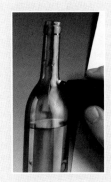

The Electric Eraser

The electric eraser is a powerful and effective tool used to achieve precise erasing in areas of shine and reflections, helpful in carrying out this exercise. This tool makes it possible to tone down color and highlight shine in a way no other tool or implement can.

The electric eraser is extremely useful for highlighting shine and softening darker colors.

the same procedure as for the bottle. Using a mask to protect the rest of the picture, carry out a first general spraying, shading the darker areas and leaving the other areas paler. Next, proceed with partial masking of the areas of shine and reflections and finally, carry out the more detailed shading with the help of moveable masks.

MORE ON THE SUBJECT

- Illustrated examples of masking **p. 36**
- Material **p. 48**

Finishing

Once you have completed the work with the airbrush, add the finishing touches. This consists of adding shine, emphasizing certain shadows, and finishing off the outlines of the reflections. You can clean up and intensify shine by using an eraser, rubbing gently in the lighter areas. To achieve perfect shine you can apply white gouache with a fine sable brush. Colored pencils are very useful for giving the perfect finish to the darker areas.

Just as we did with the bottle, start the pitcher by spraying the base.

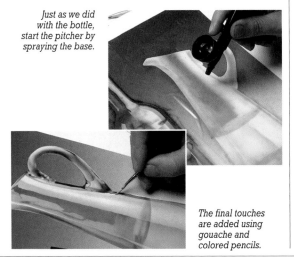

The final touches are added using gouache and colored pencils.

This is the final result, a carefully detailed image with a flawless finish.

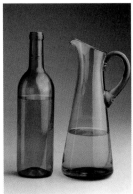

A PITCHER OF WATER

The subtlety of fading and changes in depth of color that can be achieved with the airbrush far exceed the effects achieved with any other medium or procedure. This exercise, the representation of a transparent liquid contained in a glass pitcher, is carried out with masks and fades. The airbrush will portray the subject with perfectly realistic effects.

Original Photograph

You can start with a general photographic reference or take your own photo of a specific pitcher using lighting to show shine and reflections to their best effect. If you take the photo using slide film you can then blow it up, projecting the image onto the paper. You can then simply go over the outline in pencil. As has been stressed in previous exercises, it is very important to indicate clearly on the sketch the areas of shine and reflection in preparation for the spraying, with or without a mask.

Initial Masks

Using pieces of masking tape, mask the margins: these should be 1 inch on each side. The fixed mask is placed over the pitcher, leaving the rest of the paper uncovered to allow the spraying of the background. Spray from a distance of about 16 inches from the paper. Fade the color toward the center, starting the spraying from the top and bottom of the paper. Then remove the mask that covers the pitcher. Now use moveable masks for the pitcher. Work on the inner areas of the pitcher first, spraying with differing intensity to deepen tones to indicate form. This can be achieved through spraying more than once in the same area or by using different shades of ink. A ruler and a French curve make good moveable masks in most cases. The vertical gray strips of

reflection can be depicted using a ruler as a mask; the inner edge of the pitcher can be depicted using a French curve.

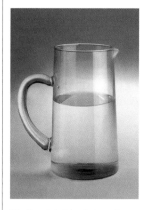

The theme is this pitcher of water on a white background, a monochrome theme that can be carried out using grays.

The surface of the water has been completed by masking the lower part. The illusion of the edge, once achieved, can be seen clearly when this mask is removed.

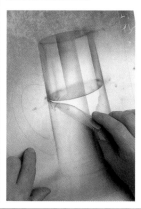

The Inside of the Pitcher

To paint the inside of the pitcher, use two different maskings. The first covers the

The airbrushing of the vertical edges can be done with a ruler, once the background has been painted and the mask of the pitcher has been removed.

Once the shine, the reflections on the glass and on the water, has been finished, mark and shade the outlines using pieces of board or thick paper cut to fit.

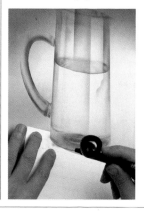

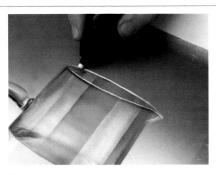

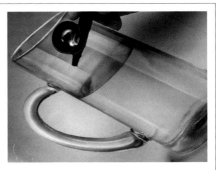

It is easy to recreate the shine on the upper rim of the pitcher using the electric eraser as if it were a pencil or felt-tip pen.

The final result has a photographic finish achieved using grays and meticulous touching up.

pitcher's lower part up to the level of the water, as well as the rest of the picture. The second mask corresponds to the upper part of the pitcher and the rest of the illustration, thus enabling you to work on the bottom half of the pitcher. While working this last part you can carry out partial maskings to achieve the luminous effects produced by the refraction of the light by the water. It is important to maintain consistency of color between the tones of the background and the water. If the color shifts too much, it looks like a colored liquid and not a transparent fluid.

Before completely removing the mask that covers the background, lift the section of mask that corresponds to the handle, then spray, taking care to model the form. Working freehand, with the airbrush very close to the paper and regulating the width of the jet, graduate the grays, which should not be too dark in tone. The darkest shades should be left for the final touches. Once you have airbrushed the handle you can remove the background mask.

Finishing

The final phase of the work consists of finishing off and highlighting the shine and transparency. This may be done freehand, using moveable masks that fit the shape of each specific area of shine and reflection. Finally, to complete the pitcher, highlight some areas of shine using an ordinary eraser and your electric eraser. In areas such as the handle it may be necessary to emphasize the shadows with a dark gray colored pencil, using gentle strokes for smooth, blended tones.

Pencil strokes should then be blended further, using a perfectly clean stump. A clean finish and convincing image is further effected by reproduction of the original. A large image that is reduced in reproduction tends to be even stronger and more effective than the original art.

Airbrushing with Opaque White

When using transparent color, the working process causes the white of the paper to darken, even in the lightest areas, due to successive spraying. Should a pure white shine be needed, you can load the airbrush with opaque white (white gouache) and spray over the area you wish to highlight.

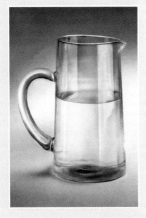

Airbrushing with opaque white hides flaws and creates new areas of shine that cover previous sprayings.

MORE ON THE SUBJECT

- Material **p. 48**
- Transparency **p. 62**
- A summary regarding shine and transparency **p. 72**

PROCEDURES FOR THEMES

A MUG OF BEER

In this next piece light and shade effects again predominate. Now the subject is a glass mug and a liquid that has coloration of its own. The transparency of the glass, combined with the color of the beer, creates a rich series of light and shade effects. There is a range of yellow here, from golden to ochre, with much subtlety and variation of detail. The color, combined with the light and the reflections on the facets, makes it necessary to work with both fixed and moveable masks.

First Phase

The work begins with the background, which means first masking the whole piece completely. Next, lift the area of the mask corresponding to the background, leaving in place the fixed masks of the mug and the margins of the sheet. The background is made up of a fade of blue, moving from a deep, solid tone at the top to one that is pale and diffuse as it drops below the middle of the paper. This fade is done with two different blues, a warm, say cerulean, and a cool, ultramarine. The lighter cerulean is applied first. The second, ultramarine, is darker, sprayed over the first in order to obtain the effect of depth in the upper part of the picture. In the lower third of the paper, a shadow is painted in a golden orange that

The result of the first phase of spraying. The background consists of two areas of fading color that merge in the center of the paper. It is important to paint in the luminous shadow that the beer casts on the base.

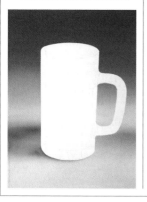

corresponds to the light filtering through the beer and onto the table.

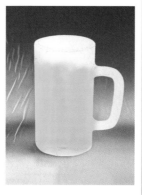

With the background covered by a mask, a general spraying is done to produce the color of the beer.

Second Phase

In the second stage of the airbrushing the general color of the beer is established, together with the main darker strips of tone. At this stage mask the blue background and the top part of the mug, from the froth's lower edge. Next the shine of the base is reserved with rubber cement or masking fluid. The color of the beer is achieved by spraying yellow, concentrating the spray for more intense zones. To obtain the darker patches that run vertically down the mug, the paint applied should be a combination of ochre, yellow, and gray, using more ochre for the areas that require a more golden tone.

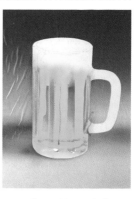

State of the work after the second phase of spraying, with the vertical bands that darken the basic yellowish tone.

The lower half of froth is achieved by spraying vertically, the top part, in a circular motion.

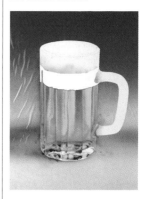

Shine and Reflection

In order to further refine the color and tones in the beer and glass, gold-tinted browns are used, which are adjusted to correspond to the tones observed

in the body and the base of the mug. Now remove the liquid mask from the base and adjust surrounding tones. The darker golden tones of beer and mug should be touched up with a mixture of yellow, red, and ochre. Working quite close to the image, with a very fine jet of paint, the darker zones of the base are outlined so that the white and yellow glints stand out clearly. Next, the masks covering the part that corresponds to the froth are removed. This is painted with a single shade of fairly light gray. To do this, spray vertically along the band that marks its height inside the mug. Then spray in a circular motion for the upper part. This last, simple procedure will suggest the color and consistency of the froth.

After removing the mask from the handle and applying liquid mask to the area of shine and to the edges of the mug, it is time to spray the transparent blues that appear in this area. The work is done freehand using moveable masks and spraying first with blue and afterwards with a neutral gray in order to intensify the darker areas.

Touching Up with a Blade

When very fine shine and reflections are required, opaque white can be applied using a paintbrush, but it is quicker and easier to use a blade to remove the paint from the paper. This must be done with great care so as not to damage the support, working with the point of the cutting knife and scraping in only one direction. Once this operation is over, a smooth rubbing with an eraser may be necessary to rid the paper of small shavings of paint that the blade has lifted.

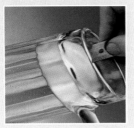

The cutting knife is a great help for obtaining shine and highlights in pure white (on white paper). It should be used with care so as not to damage the surface of the support.

Perfecting

When the second phase has been completed, the artist can then make a choice to either stop here, the image being developed to a realistic point, or further develop it, for a more dramatic look. Taking the second choice, to explore the capacity of airbrush at its best, slow, careful work is necessary

to perfect the finish. This high finish is achieved by touching up the glints with a white colored pencil, toning the edges to make their volume stand out. Next, erase the areas that require a brilliant shine, and make any other touch ups to further heighten the effects of light and color that have been developed throughout the work.

MORE ON THE SUBJECT
• Material **p. 48**
• Transparency **p. 62**
• A pitcher of water **p. 64**

A white colored pencil is used to define the glints and shine in the glass.

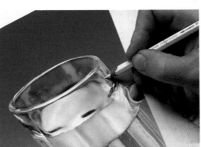

Final result of the work after finishing the details.

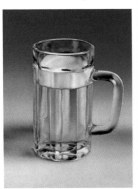

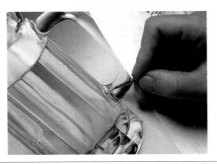

The small irregular glints in the handle can be done using white gouache applied with a paintbrush.

A DISH OF ICE CREAM

The next exercise is more complex, yet continues to build on the techniques already explored. The theme is a glass dish of ice cream and is a type of illustration often seen in cafeterias and restaurants. Added to the shine, transparency, and reflection of the glass are the textures of the chocolate, the ice cream, and the strawberry. Freehand spraying and liquid masking are central to the technique used for this piece.

Texture

The success of this piece rests on achieving the varied textures that the subject presents. Airbrush has the capacity to reproduce a wide variety of textures, but is especially suited to surfaces that are polished, shiny, or transparent. When used for the purposes of advertising, a theme such as this dessert will need to be interpreted in a more than real way for the sake of appeal and persuasion.

As always, the first step consists of making a drawing from a photograph of the dish of ice cream. Whether it is done by projecting the image or by tracing, the resulting drawing must be precise in all its significant details, the outlining done with very fine lines.

Masking with Liquid Mask or Rubber Cement

The complex network of shine and reflections that make up the glass dish can be achieved without the aid of any masks, other than small areas of liquid masks to reserve shine. Using a fine, pointed paintbrush to apply the liquid mask, go over all the lines that, in the original picture, represent the shine and the reflec-

tions. Once dry, the liquid mask will reserve the white of the paper. Now the rest of the illustration is masked; just the area of the dish is lifted off for painting. The glass surfaces are then sprayed with light gray, shading just the areas below the forms of the dessert. A few light sprayings of pink and yellow, indicating the presence of the spheres of ice cream seen through the glass, should be laid over this light

Protect the background with a general mask and reserve the most important patches of shine with liquid masking or rubber cement.

Remove the liquid mask with a rubber cement pick up and the shine created at the first stage appears.

Preliminary drawing showing the limits for the masks.

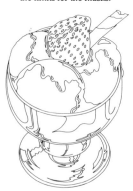

After spraying with gray to give the quality of glass, spray light patches of the colors of the ice cream to create the effect of transparency.

With only the masks for the spheres of ice cream lifted, the corresponding colors for these areas are sprayed.

When spraying is over, some glints can be defined using white gouache and a paintbrush.

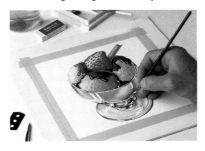

Spattering with a Toothbrush

For this exercise a simple trick can be utilized. This consists of splashing paint with the aid of a toothbrush to obtain the fine mottling that characterizes the surface of the ice cream. Simply moisten the bristles of the toothbrush with paint and tap the brush with a finger to splash its content of paint onto the picture. This should be done with great care, the area to be spattered bordered with protective masks so that the splashes do not affect other parts of the painting.

A simple toothbrush can be used to create spattering to heighten the texture of the ice cream.

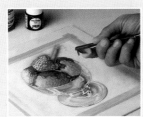

MORE ON THE SUBJECT

- A mug of beer **p. 66**
- A summary regarding shine and transparency **p. 72**

gray. When the paint is completely dry, the patches of liquid mask are removed using a rubber cement pick up. The reserved areas appear completely white and suggest the effect of the shine on the glass dish.

The top part of the image, the ice cream, chocolate, and strawberry, should be done by unmasking the areas corresponding to each one in its turn. When spraying the colors for these, bear in mind what we have already learned for the spherical forms of the ice cream, spraying more intensely toward one of the sides to suggest shade. Painting the strawberry requires a technique that we have explored in an earlier exercise, which consists of applying the liquid masking to represent the characteristic dimpled surface of this fruit. The shine on the chocolate is done using the same method as for the dish:

reserve the white areas with liquid mask applied with a paintbrush. The texture characteristic of the surface of ice cream can be obtained by spraying the paint in short bursts, very close to the paper, taking care not to overspray.

Final Touches

The final touches consist of the definition of light and shadow on the glass of the dish. Although the shine has been achieved using liquid mask, the bulk of the dish still looks flat and the modeling of the base is not yet clearly defined. To carry out this aspect of the illustration, shade is created using a dark gray pencil. Care should be taken not to press too hard, to avoid marking. The tones needed can be achieved by laying down very light color in several layers.

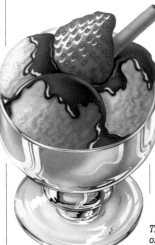

The final result. This exercise offers a combination of different textures.

TRANSPARENCY WITH MOVEABLE MASKS

As a complement to the representation of crystal and glass, in this chapter we propose a work based more on smooth blending than on the contrast of colors. The subject is a still life consisting of colorless glass objects that can be painted in a single color that is graded into different intensities. The exercise can be carried out without adhesive masks, just by using moveable masks.

Background Color and Transparency

The painting of the background color is the first important step in creating a representation of transparent surfaces. Following that must come the construction of the shapes of objects, using smooth, dark lines of differing intensity. Overlaying the shine and subtly blending lights and shadows, letting the background color dominate and show through, will complete the image. The background color need only be altered where an outline has to be drawn, or an edge made to stand out. The volume of the objects will be carried by the correct placement of reflections. For the background a medium-toned opaque cover-

The background is sprayed over the preliminary drawing, which is redrawn in black pencil to make the outlines again visible.

ing should be used, applied in gentle sprayings so as not to darken the paper too much. Shine requires an opaque white for maximum clarity.

MORE ON THE SUBJECT
- Illustrated examples of masking **p. 36**

The Initial Drawing and the Background Color

As always, the drawing must be as precise as possible in regard to outlines, size, and placing of the objects. This should be done by some means of projection or tracing, using a hard, well-sharpened pencil so that the lines are fine and precise. Next, this drawing

Several different moveable masks are cut out of board to create the curves in the subject.

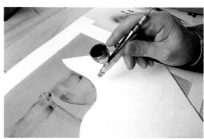

Result of the first spraying, carried out with the aid of moveable masks to give shade to the main outlines.

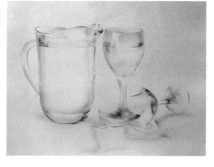

Symmetrical shapes can be obtained by using both sides of a curve.

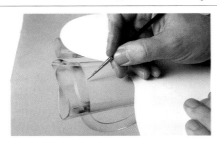

To make the tiny glints on the surface of the water stand out, use a fine paintbrush and opaque white.

White Colored Pencil

A white colored pencil does not cover as well as brushstrokes of gouache or acrylic. For this reason a white pencil may be used for creating transparent shine effects, such as those that appear in the shadows on the table in this composition. White pencil used in this way creates a very convincing appearance of glass-filtered light.

The semi-opaque quality of the white colored pencil effectively reproduces certain light effects.

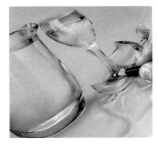

As a final touch, a black pencil puts in the shade at the base of the glasses.

is gone over with a dark gray colored pencil. The lines indicated in the photograph should be emphasized. Some light shading should be done, giving an initial, basic impression of volume to the work. Next, the background color can be sprayed on. This is merely a general spraying to darken the paper slightly, so the white of the shine, which will be sprayed in opaque white, will be differentiated.

Moveable Masks

The painting and development of this composition is done entirely with moveable masks. These pieces are cut out from stiff paper or board, and laid down on areas to be reserved before spraying. The masks are cut out to approximately imitate the curves and outer edges of the objects. Only approximation is necessary as the masking is adjusted to the shape while working, moving the mask as needed while spraying (this is why they are called moveable masks). It is important to have all your cutouts ready so that you are able to select the most suitable one for each edge as you work.

Using the appropriate curved piece, spray lightly with the background color, slightly darkened with black, following the pattern of tone and volume indicated by the photograph. Do your shading little by little, and fragment by fragment. One curve may be used for each of the symmetrical sides of an object by simply reversing the mask. The whole of the illustration can be worked in this way. The shine and the white areas are sprayed in white acrylic or gouache.

Touching Up and Defining

In this composition a fine sable paintbrush and gouache are especially useful for depicting tiny glints and reflections on the surface of the water, the bases of the glasses, and any of the sparkle on the surface of the glass. The gray pencil can be used again to heighten any edges that have become blurred, or to deepen a shadow.

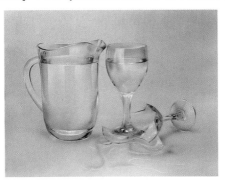

Final result: A complete group of transparencies.

A SUMMARY REGARDING SHINE AND TRANSPARENCY

The following is a summary of the variety of techniques and procedures that have been used so far to depict polished, shiny, or transparent surfaces. All the procedures we've used are variations and elaborations of a few basic techniques. However, one aspect or another will dominate, depending upon whether one is working with glass, metal, or some other burnished surface.

Shine: Opaque and Transparent Colors

In order to correctly depict lacquered or shiny surfaces you must combine opaque and transparent areas. Transparent colors add dimension to shine and reflections, and effectively depict volume through the use of fading. Opaque colors are used to emphasize the darker shadows and reflections that dark objects cast over a surface. To combine both techniques, use the transparent tones first as they will not affect the dark, opaque surfaces. The transparent colors most frequently used are liquid watercolors and inks; the dark opaque colors are gouache and acrylics.

Shine and Fading

On curved, shiny surfaces the luminous effect is achieved through fading. Normally this fade consists of a dark reflection that is softened until it transitions to the white of the paper. A chrome surface acts as a kind of distorting mirror that not only reflects nearby objects but also the lights of other reflections. These lights are depicted with gentle fading, achieved by spraying from a middle distance so that the outlines of the strokes are blurred. The white of the paper is used to function as areas of maximum light.

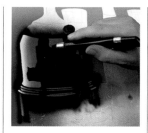

Shine, on a lacquered surface, is patterned with dark shadows.

Reserving Space or Masking with Rubber Cement

Whenever one has to depict the shine and reflections of curved surfaces, minor problems arise that can be solved by reserving areas with rubber cement. It is important to use an inexpensive brush for this as the cement dries very quickly, barely leaving time to clean the brush properly. The solvent for rubber cement is rubber cement thinner, and the brush should be cleaned with it immediately after each use. Rubber cement is useful when working on details that can be painted in a few swift strokes, but never for larger areas because the process becomes too complicated. If the detail is very small, after removing the rubber it may be necessary to touch up the outlines with colored pencils or gouache.

When working on burnished or shiny objects, the illusion of luminosity is achieved through multiple fades.

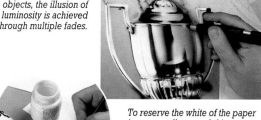

To reserve the white of the paper in very small areas of shine, use rubber cement.

An important consideration when depicting transparency is reserving the white of the paper under areas of sprayed transparent paint.

Color and Transparency

Transparent objects often have no color of their own. Their convincing depiction rests on the consistency of the background color as seen through their transparent material. Spraying is done in gentle overlays indicating their outlines, volumes, and shadows. Shine, done with opaque white, further models their forms.

Reflections on Polished Surfaces

A polished surface that is neither chrome nor burnished reflects like a dark, smoky mirror. The reflections of objects are shadowy and only their outlines are clearly highlighted. A standard procedure is to work this type of reflection using fading, which clouds both color and shape, implying or giving an impression of, rather than depicting the details. A characteristic composition in which these reflections can be seen is one in which objects are placed on a lacquered or highly polished table.

> **MORE ON THE SUBJECT**
> • Materials **p. 48**

Colored glass requires careful blending of shine and reflections within the range of shades closest to the actual color of the glass.

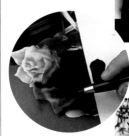

Reflections on lacquered surfaces are depicted by darkening the colors and emphasizing the outlines.

Touching up freehand is necessary when the details are too small to depict with the airbrush.

Colored Glass

Colored glass presents a transparency attenuated by its own color or that of the liquid it contains. A composition of this sort should be worked on a background of white paper, so that the transparency of colored glass is unaltered by background color. Transparent pigments should be used, faded and deepened by repeated spraying. Darker shades should be superimposed in layers.

Touching Up Freehand

Working freehand is done without the aid of masks of any kind, stencils, or even rubber cement. Work of this sort is highly dependent on the artist's skills and experience, as well as on the look that is wanted for the finished piece. The systematic use of masking gives perfect, precise results, but they are usually mechanical and lack warmth. Finishing off details with a brush or a colored pencil always adds a personal touch to your work.

Objective: Realism

Most often in airbrush work the artist is striving for a perfect representation of reality, further emphasized by the brilliance and luminosity characteristic of the airbrush. Though the process may seem mechanical, there is much creativity involved. It is upon the artist's sense of color and crafting that the strength and beauty of the piece rests.

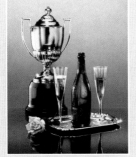
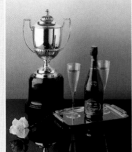

The differences between the original photograph and the illustration lie in the artist's interpretation and emphasis, but not in realistic precision.

SHINE AND REFLECTIONS ON METAL

At first glance, it may appear very difficult to depict the shine on a chrome surface. If one were using media such as watercolor or oil it would be difficult indeed because their consistency impedes the achievement of a perfectly clean finish. However, for the airbrush artist these are the subjects most easily represented, showing off the medium to its greatest effect.

Preparation

It is essential to begin with a good photograph of the model. One of the factors that make chrome surfaces especially challenging to depict is that the slightest shift in viewpoint completely alters the areas of shine and reflections. Working from a photo eliminates that problem. If the photo is the right size, the outline can be traced onto the paper, working on a light table. If the image is on a slide, it can be projected onto the drawing paper. Whatever mode of transfer is used, make sure to use very fine, precise lines, clearly marking the general outlines and shape of each area of shine and reflection. Placing the mask over the picture, cut out its different sections using the lines of the photo as a guide, and using rulers and stencils as an aid. As always, the initial spraying is of the background

MORE ON THE SUBJECT
• Materials **p. 48**

The photo used as a model for the exercise.

Having covered the faucet with a self-adhesive mask, color in the background with a violet-blue intensified with black along the lower edge.

Cut the mask in the areas that represent the darkest reflections. The background and the lightest areas of the faucet remain covered.

and is carried out after covering the body of the faucet with a mask.

Shade

Artists work with pigments and colors, to create the illusion of light. To successfully depict areas of shine, light, and reflection, their luminous effects must be suggested by the darkening of adjacent areas. The whites of the paper, as well as white painted areas, will appear bril-

liant by contrast with shadows. One characteristic of chrome surfaces is that shadows appear perfectly outlined, creating stylized shapes that are easy to cut out of the mask. Keeping the faucet area completely covered with the mask, cut out these shadow shapes, remove them, and mask the background. Spray over the exposed areas with a fairly thick, black gouache. The con-

Gently spray the central and upper areas of the faucet using a paler gray to depict the intermediate shades.

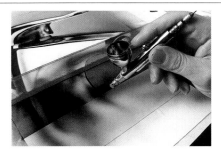

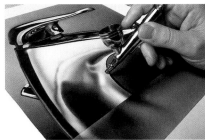

The base of the faucet is done by reserving the upper part with a moveable mask (paper or board).

Spraying with opaque white you can complete the area of shine and reflections on the lower part of the faucet.

sistency should be thin enough, however, to flow through the nozzle without blocking. Once this is done, put back the cutouts and lift off the mask that covers the body of the faucet. Next, spray the irregular shading of the base. This can be done freehand, superimposing sprayings until you achieve the diffuse and distorted shadows of the faucet's contour. The bluish area that appears in the bottom part of the picture can be achieved by protecting the rest of the illustration with a piece of paper and spraying first with pale blue, then with a darker blue.

Details

In this exercise the finish is very important. Between the shadows and areas of shine there are complex areas made up by the small pieces of the faucet. These should be worked on using more precise tools than the airbrush. The opening of the faucet contains a small grille that can be painted with a brush, highlighting the shadows with a black pencil. Some shiny lines can be depicted by scratching over the black with the edge of a razor blade. Apart from these fine details, the freehand shading should be completed and highlighted with light sprayings of white, which soften the black areas. Using opaque white (white gouache), superimpose some light spray-

ings that emphasize and create areas of shine between the shadows. The tiny reflections on the lower part of the regulator

and the opening of the faucet can also be touched up using white gouache and a fine sable brush.

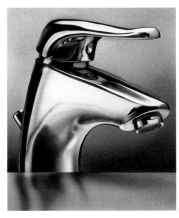

The final result, after finishing off the details by scraping with a razor blade and highlighting shine with a pencil.

Original and Reproduction

As a general rule, illustrations that are to be printed are done much larger than the size in which they will be reproduced. Reduction causes details to appear more focused than they really are. So, while working with these details requires the utmost care and attention, one does not have to work using a magnifying glass. The larger the original illustration, the easier it will be to finish off the details correctly, and the handsomer will be the published piece.

Working in a format that is far larger than the size in which it will be reproduced makes it easier for the artist to finish off the details comfortably.

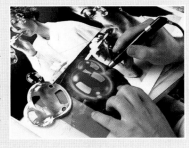

A CLASSIC AUTOMOBILE

The subject of this exercise is a very common theme, often used in posters for movie theaters, clubs, public establishments, and so on. Automobiles, particularly this one of vintage era, have great appeal, particularly for an airbrush painter, because of the rich harmonies of its volumes, its reflective luminous effects, and its mirror-like chrome.

A Very Careful Drawing

Time and patience need to be taken in the first stage of this project, the preliminary drawing. Outlines for the volumes of the body, hood, fender and grillwork, as well as delineations of areas of shine and reflection must be executed with great attention to detail and accuracy. The careful drawing of all these shapes, which will become areas of color, will make the subsequent painting much easier to do.

Masks and Reserves

The surface area of this automobile is made up of many small shapes and configurations of color and shine. Begin by preparing masks for the large areas, which can be cut out with a certain amount of ease. The smallest areas of shine will be masked using rubber cement or liquid mask-

ing. The careful preliminary drawing proves vital at this point, leaving nothing to chance or improvisation. The reserved areas of liquid mask are very easy to do when the drawing is well done.

The Blue and the Shine

Once the larger masks for the blue of the body work have been cut and lifted off, liquid masking or rubber cement can be applied to those areas that are too small or intricate to be masked in other ways. The blue areas should then be sprayed, trying to achieve an even tone. In order to paint the areas with more shade, the airbrush should be loaded with a darker blue to represent the shadows. The most significant shadows are located on the side of the hood, the right side, and the interior ceiling of the car. To paint the shine, again cover the parts that were unmasked previously and remove the cut out sections of mask that correspond to the lighter areas. Allowing some of the white of the paper to show through, spray with a medium gray, using fading to model form.

The small area of shine on the bodywork should be masked with liquid rubber.

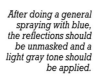

After doing a general spraying with blue, the reflections should be unmasked and a light gray tone should be applied.

Preliminary drawing; a detailed line drawing delineating areas for lights, shade, shine, and reflections.

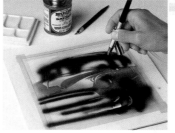

Mask the bodywork again and uncover the interior. The areas that have the most shade should be sprayed with black.

Dark Shadows

Next, the darker areas should be shaded in with black. As always, you will need to cut out masks which, using the picture as a guide, delineate the outline of the shadows. These shadowed areas can be found at the front of the automobile as well as in its interior, the interior of the fender grillwork, and wheels. For the other areas of the fender, sections of mask should be cut out and removed to spray, using a light fading process and a medium gray tone.

The Subject of Automobiles

Cars and vehicles in general have a natural appeal for the airbrush artist. The medium so effectively represents classic models with their luxurious appearances and sleek designs. Airbrush painting best displays its virtuosity when representing such industrial type finishes, sleek reflections, metallic tones, chrome, the effects of transparency and glass. The example of this illustration, and the techniques explored to develop it, are a good demonstration of this.

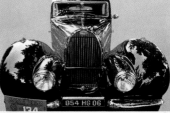

Example of the graphic brilliance that can be achieved in an airbrush illustration of an automobile.

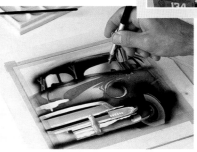

A medium gray tone should be applied to the metal of the fender and a lighter gray to the glass and chrome of the wheels.

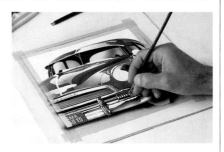

The last details should be applied using a paintbrush and gouache.

Details

Working with masks, from this point on, becomes impractical. The details are so small that it would be difficult to control the airbrush, and it is better to continue with a paintbrush. Using the same colors that you have used for the shadows, use the paintbrush to touch up the details of the radiator. Continue by highlighting the shine of the fender, the colors in the glass of the headlights, and all the other areas of shine that need detailed attention. Working with a paintbrush is much more direct than with an airbrush. Because opaque color is used you can correct over painted areas without worrying about reserving areas of white. The time taken to put careful finish-

ing touches on this piece is time well spent. The result will be an automobile with a slick, polished finish, and a strong, attractive composition.

MORE ON THE SUBJECT
- Material **p. 48**
- A summary regarding shine and transparency **p. 72**
- Shine and reelections on metal **p. 74**

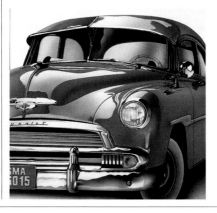

The final illustration. An extremely graphic and appealing result.

A TECHNICAL ILLUSTRATION

The following illustration of a camera requires many steps to develop, and will take time and patience. It involves the use of more than one hundred masks to precisely depict its many mechanical details. Though it is not strictly necessary, the use of two airbrushes will facilitate the work. If using two, one should be used for light colors, the other for dark colors. With two airbrushes less time will be spent cleaning and refilling. Given the complexity of the illustration, it is a good idea to work on a large scale, one and a half to twice the size of the required measurement for reproduction, as the reduced image will appear greatly enhanced.

Preliminary Drawing

It is important to start by preparing a highly detailed preliminary drawing because this will enable you to paint all the mechanisms with precision and accuracy. If the original photograph is very small, it is advisable to enlarge it by photocopying in order to work more comfortably. The enlargement should then be traced onto tracing paper and transferred onto the drawing paper. Smooth illustration board makes a good surface for this illustration so that all the details will be crisp and clear.

First Masks

Once the drawing has been completed, the illustration should be completely covered with a self-adhesive mask, laid down with care, so that no air bubbles occur. Now begin the cutting out and lifting off process as you deal with each area. Sometimes, and when the area is big enough, you can use a ruler for straight outlines or cut out a paper stencil to obtain a crisp outline. All this forms part of the first stage of the work. Next, the main shape of the camera will be sprayed with a light cover, black for the shade and a bluish-gray for the lights.

Second Group of Masks

Once the outside has been dealt with, you will find that it is quite difficult to know exactly where you are in your work as the mask will have been over-sprayed several times. It will, therefore, be necessary to remove all of the original self-adhesive mask and cut out and lay down a new one. French

The original photograph should be enlarged to a much greater size in order to be able to work comfortably with its many details.

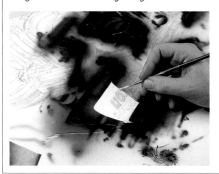

The glossy black areas of the camera should be painted freehand, fading the area of shine and using a ruler to create straight edges.

Improvised masks of the larger areas can be cut to size to reserve the adjacent areas.

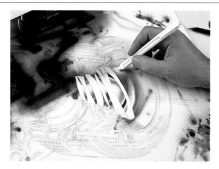

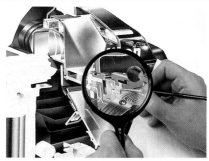

The best way to obtain the dull shine of the lens is by using an eraser.

It is necessary to use a magnifying glass to be able to deal with the minute details. A paintbrush should be used to touch these up.

curves can be used for this second stage as long as they can be adjusted to the limits of the drawing. Otherwise you will have to cut out masks following the design of the original. It will also be necessary to reserve areas of white with liquid masking or rubber cement, particularly in the lettering of the brand name and the inscriptions on the lens. At the end of this stage, all the outside, and fading in grayish blue on the glass, mirrors, and the lens should be touched up.

practically all its many parts will require fading, shine, highlights, and using variations of the same color.

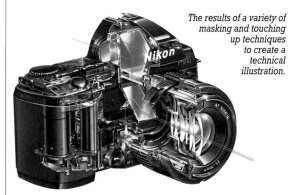

The results of a variety of masking and touching up techniques to create a technical illustration.

Painting the Details

In order to deal adequately with all the minute interior details you will need to alternate the use of self-adhesive masks, moveable masks, gouache paint, colored pencil, and a fine tipped technical drawing pen. This last tool is very useful to define the outlines of the smallest pieces and to darken the tiny shadows in the corners. You can also use an electric eraser to lighten the colors and to bring out some of the shine. Many tools and materials available to an artist can be utilized to create this illustration, which is so full of minute details. In this work

Technical Accuracy and Creativity

The painting of details and technical precision that are characteristic of the airbrush does not mean that you cannot use your imagination. In fact, one area in which the airbrush is quite appropriate is science fiction. This kind of artwork mixes both technical precision and creativity. Many airbrush illustrators are known for their work in science fiction illustration.

This extraordinary illustration by Chris Moore is highly creative and full of technical expertise.

MORE ON THE SUBJECT

• Transparency with moveable masks **p. 70**

SKIN TONES

The problems of light and shade, of modeling and texture, when applied to skin present interesting problems to solve, which we will examine next. The challenge here is to mix suitable flesh tones for each spraying, as well as getting these tones to function together visually on the paper. Colors must be mixed and painted with subtlety, to give the convincing appearance of flesh.

Lifelike Skin Tones

Painting the human figure is always challenging. Flesh tones and colors, and their modeling to create volume, are central in this study. Natural color needs to be accurately reproduced. This takes some analysis and observation. Invention does not work well as far as skin color and tone effects are concerned. Rather, a good, clear photo that effectively represents skin color, its tones and shadows, should be used and followed carefully as a model. Although nearly all manufacturers sell a flesh-colored paint, its use is not advisable as it tends to have an artificial aspect.

Overspraying

Starting off with a photograph such as the one pictured, the handshake, begins as does any other composition, by transferring it onto your paper with a careful line drawing. The background should be sprayed first with a fade of dark blue. Then remove the mask and carry out the painting of the hands, first with a gentle spraying of sienna, which creates the basic volume of the fingers and the knuckles. This task should be done freehand, without any masks and by careful copying of the photograph. Care should be taken not to exaggerate the forms

and volumes or to reduce this to a flat surface of color as the hand is easy to distort if not depicted accurately. Next, spray over the sienna with yellow, for warmth of tone and to color the parts that have the most light.

Ranges of Skin Tones

The handling of skin tones cannot be reduced to a formula as each picture is unique. For

> **MORE ON THE SUBJECT**
> • Material **p. 48**

Model in which the skin tones are lightly shaded and maintain a warm tone.

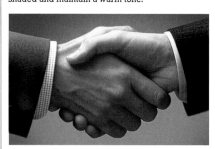

After spraying the background, the mask should be taken away in order to work with the skin tones.

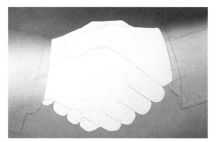

Using a coat of sienna, the first lights and shades are created, as well as the general volume.

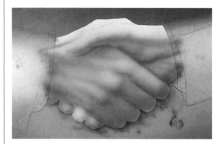

Natural shade should be added (a color that is darker than the base color) to intensify the shadow.

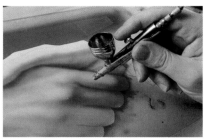

The consecutive sprayings have produced a pictorial richness in the skin tones.

The small details that correspond to the wrinkles and the hair should be touched up.

Using an eraser, open up some lighter patches to represent the characteristic shine of the skin.

The final result, a polished, realistic reproduction of the photo.

one thing, conditions that greatly affect shades and toning are an important variable, and skin color and pigmentation differ from person to person. Although you may have a good color photograph it is wise to also observe and analyze the chromatic variety of your own or someone else's hands. In this photo there are pink and oranges that dominate the light areas, and green and blue tones in the shadows, together making up a coherent unit. All this great variety of color is used in a subtle way, without obvious contrasts. The color is applied with gentle transitions for a realistic look.

Correcting Errors

Sometimes accidents can happen and the illustration can be spotted by accidental splashes. If the spot is too big to be rubbed out with an eraser, you can spray over it with opaque white to color the area again. The transition between the corrected area and the rest of the work should be completely unnoticeable.

To correct errors which cannot be rubbed out, spray with white over the area and repaint.

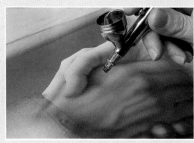

Realistic Finishing

Skin tones and texture, which is smooth and vital, demand a specific finish to characterize and represent them well. This finish is typical of the airbrush's satiny, sleek look. A realistic illustration often calls for the treatment of wrinkles, the characteristic shine of the skin, some details of the hair, and all kinds of nuances. Many of these details should be done in the last stages, touching them up with colored pencils, highlighting slight shine by rubbing out. Light sprayings of paint will unify the work, softening contrasts and transitions.

FACES AND HAIR

Within the subject of painting the human figure, the face can be most challenging. Yet representing the face continues to build on all we have thus far learned. It is a further elaboration on the theme of skin tones. Having already solved many previous problems of volumes and flesh tones will help approach depicting these volumes and tones to represent the features of the face.

Faces

Faces and hair work together to form an attractive realistic treatment of the head, though each poses different problems. The approach to the hair and face in traditional, classical painting is to work these elements almost simultaneously. The traditional artist corrects, places emphasis, and makes adjustments as the painting develops. But this method cannot be used by an airbrush artist. When working with an airbrush you must foresee not only the solutions to each aspect of the work but also the order in which these solutions will be put into practice. In addition, working with masks hinders the view of the work's progress as a whole. Still, it is essential that the artist have a clear idea of the result he or she is aiming to achieve. Since, in the majority of cases, the airbrush illustration is based on one or more photographs, it will be the photograph that sets the guidelines.

When depicting the face, volume and skin tones play the dominant role. Photographic highlights, shine, and emphasis of light can be reproduced very well with an airbrush thanks to the softness of the fading process. As far as the color of the skin tones is concerned, a certain amount of skill, practice, and analysis are needed for appropriate color usage. These mixtures are usually composed of burnt sienna, orange, ochre, crimson, and some amounts of blue and green for shadows. With this color system and with the aid of the color photograph, you can begin the study of the face with confidence.

MORE ON THE SUBJECT
• Illustrated examples of masking **p. 36**
• Material **p. 48**
• Skin tones **p. 80**

Painting hair also requires liquid masks for the shine.

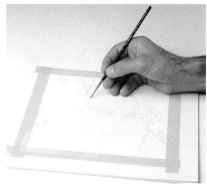

The first applications of color are general. The spraying should suggest the locks of hair.

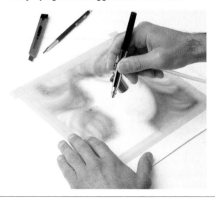

After spraying, the liquid mask can be removed.

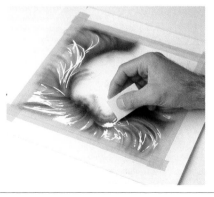

The contrast of shine can be softened with oversprayings of the same base color as the hair.

Once the face has been completed, the gradual change of color from the skin tones to the hair should be softened.

Hair

Painting hair in a convincing way is one of the best capacities of the airbrush, as far as its shine and texture are concerned. The silky and glossy hair in advertising artwork is a typical theme for the airbrush artist. The soft and luminous transition from light to shade in shiny hair, waves and curls, and endless hairstyles are represented with great virtuosity in airbrush. Though it requires some patience, painting hair with the airbrush is easier than it may seem. First, create a base of color. Transitions between volumes are made by fading from light to dark. This soft fading that the airbrush allows you to do will perfectly represent the look of hair. Building on this base, paint details, volumes, masses and locks of hair, as well as stray hairs, painted with a paintbrush, colored pencils, and by using liquid rubber masks. The work of unifying the image will take some time. Lights and darks and transitions between them are key. Use the illustration to cross-reference your work.

Features

The structure of the facial features are based upon the geo-metric forms we have explored earlier. Because of their small size and detail they are best finished with a paintbrush and colored pencils. The basic forms are first established by general spraying. The transitions between features and the planes of the face are created with light spraying, as well. The transition from forehead to the roots of the hair are particularly important and must be kept soft. Any harsh lines created by masking should be toned down at this point.

Sensitive Modeling

The airbrush allows you to get a slightly out-of-focus photo-graphic effect that is widely used in advertising for its elegance and its luminous, atmospheric effect. To achieve this look one must work carefully from the original photo, softening contrasts and tone changes, as well as any harsh transitions caused by masking. Touch ups must be done delicately. In this illustration, skin tones and hair are unified with a slightly out-of-focus, atmospheric finish. The look is one of sophistication.

The silkiness of the hair and the softness of the skin tones are achieved by using gentle spraying, which creates a realistic effect.

HUMAN FIGURES WITH THE AIRBRUSH (I)

Rather than working from photographs in this next exercise, we will work from drawings and imagination. A variety of masks will be used, both fixed and moveable. Also, the range of different effects that can be achieved with an airbrush will be explored.

An Invented Scene

Precision in the preliminary drawing, as when working from photographs, is also essential when working from sketches or from a drawing. The preliminary drawing for the present exercise should be done precisely down to its smallest details as the masks have to be cut out with absolute accuracy for each one of the areas that you are going to reserve. Mark the limits of each area of the illustration so that you know exactly which areas will need masking. The drawing will, in effect, represent a schematic of the masks. The larger areas, to be painted freehand, will, of course, be less detailed.

As always, tape the edges of the illustration with masking or drafting tape so that the margins of the image painted with the airbrush will be perfectly squared.

Masks

The clouds can be masked with cotton fiber, as demonstrated earlier in the section on clouds. Pieces of cotton fiber are stuck to the support with small pieces of adhesive tape or with rubber cement. Use the cotton generously, but without too much compression so that the blue of the sky appears subtly through the white after spraying. Thanks to the texture

The initial drawing is a careful work up of the composition to be developed, a perfectly accurate line drawing.

of the cotton fiber, the color is filtered as it is sprayed, producing a fade effect almost impossible to imitate working freehand or without this type of mask. For the mountains in the background, in blue, you can use a solid moveable mask made with torn paper. This mask will protect the paper above the level of the horizon. The protection of the area of the mountain

itself will be done with a self-adhesive mask. Next, the figure should be masked, while painting the background of countryside. The background once painted is remasked to do a general spraying of the basic skin tones of the figure. When this sequence is completed, moveable masks and touching up will be done, as well as fine finishing.

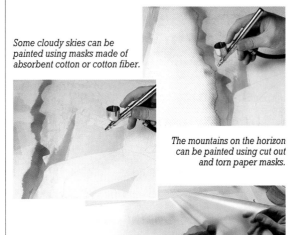

Some cloudy skies can be painted using masks made of absorbent cotton or cotton fiber.

The mountains on the horizon can be painted using cut out and torn paper masks.

After a general freehand coloring, the entire picture is masked.

MORE ON THE SUBJECT

- Materials **p. 48**
- Skin tones **p. 80**
- Faces and hair **p. 82**

Faces and Hair
Human Figures with the Airbrush (I)
Human Figures with the Airbrush (II)

85

The Head and the Hair

Self-adhesive masks should be used next for the head of the figure, placing the masking around the hair, leaving the area to be painted exposed. Before spraying, a series of curved lines that represent the shine of the hair should be reserved using liquid rubber. Now the area of the hair is painted, the mask next being lifted off by using a rubber cement pick up. To be able to get the shade of the volumes and masses of hair, masks of heavy paper can be used that are incised with curves of different widths and lengths to imitate the forms of the hair. Alternate the use of these, using various sprayings to get the desired effect. This part of the work should be done while the face is still covered by the self-adhesive mask. Rubber cement can be used to produce the reflections of the sun in the lenses of the glasses. The rest

The painting of the hair can be done by using masks of cut out paper.

The Use of French Curves

In this illustration French curves have been used to outline the edge of the table. These are very useful and simple to use. Almost any kind of curves, regular or irregular, can be represented by using these stencils correctly, often by combining them. This method is quicker than using self-adhesive masks. Take care as you work to keep control of the spraying, protecting areas that should be reserved.

French curves are very useful for defining small, curved outlines.

of the details of the figure, such as the lips, or the hair, or specific areas of shine, will need to be painted carefully with a paintbrush and gouache.

Still Life with Fruit and Cocktail

To paint the still life in the left portion of the illustration,

first mask the surrounding area with a self-adhesive mask. Paint the watermelon pits by hand. Carefully spray the area around them for the texture of the red pulp. The glass and the cocktail shaker are worked using shine and reflections, similarly handled as in earlier exercises representing glass and metallic finishes.

There are various solutions for painting the still life in the foreground, for example using circular and oval stencils.

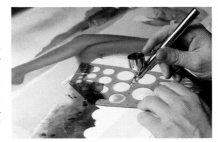

The final touching up should be done with a paintbrush and gouache, and colored pencils.

The final result. An invented scene, realistic and convincing.

HUMAN FIGURES WITH THE AIRBRUSH (II)

The purpose of the next exercise is to review and summarize the techniques already
presented for the representation of the human figure. Depicting the figure's volumes
and forms, skin tones and hair, as well as the complex masking techniques required,
will again be sequenced for this complex, detailed, highly defined image.

Enlarging and Polyester Masks

The subject of this illustration is the head of a woman who is blowing soap bubbles. It is taken from a photograph that will need to be enlarged so that details can be seen and developed meticulously. The enlarged photocopy will next be traced onto the paper. A polyester or self-adhesive mask should be placed over the drawing, then cut into sections following the external outlines of the figure and the hand. Polyester self-adhesive masking will need some rubber cement to fasten properly. Immediately after laying down and cutting out the self-adhesive mask, remove the area of masking that covers the background, leaving the figure covered. Next the background should be sprayed with a dark blue, several layers, until it is deep and intense. As it is a large background and will require prolonged spraying,

Having cut out the polyester mask and covered the figure, the background should be painted.

Warm Temperatures and Types of Mask

If you work in a warm climate or temperature, when the self-adhesive mask is removed it may leave a residue that will cause defects in the finish. When that is the case it is better to use a polyester mask, which needs to be stuck to the support with rubber cement.

The polyester mask should be stuck to the illustration with liquid rubber glue. The glue comes away completely once it is dry if you rub it with a cotton cloth or a rubber cement pick up.

protect yourself with a face mask so that you do not inhale the sprayed paint. When the background has been painted, the mask over the figure is next lifted off. Details such as the

The straw should be masked with liquid rubber so that it is not affected by the spraying.

straw and the bubbles should be reserved with liquid mask. The head and the hand are left uncovered so that you can paint the first spraying of the skin tones. These first coats are applied close up to concentrate the shading of the nose, eyes, and mouth.

Skin Tones

The base color of the skin tones is an intense orange, which provides a good support layer for the hues and tones that will overlay it to make up the flesh color. These tones range from dark sienna for the shade to touches of crimson, including very slight applications of ultramarine blue. To mask the forehead and the roots of the hair the original photocopy can be used as a stencil. Then paint partly freehand and partly with the loose aid of a stencil to outline details

Human Figures with the Airbrush (I)
Human Figures with the Airbrush (II)
Retouching Photographs

87

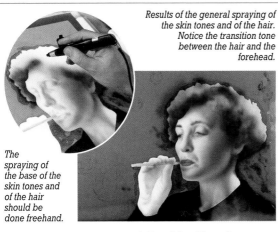

The spraying of the base of the skin tones and of the hair should be done freehand.

Results of the general spraying of the skin tones and of the hair. Notice the transition tone between the hair and the forehead.

such as the corner of the mouth and the nose. Now the first sprayings of the skin tones of the hand are applied. Further precision for these can be achieved by finishing with colored pencils, using gouache to define the features of the face and the details and wrinkles of the hand. As the image develops you may need to add darker touches if necessary. Finally, soften the contrast of the figure against the dark background by gradually darkening the shadows.

Touching Up and Finishing

Once the skin tones have been finished, the general mask

of the background is removed as well as the mask covering the woman's blouse. The liquid masks for the straw, the earrings, and the lip gloss are taken up with a rubber cement pick up. All these areas should now be touched up, the transitions between colors softened so that the contrast with the pure white of the paper is not too harsh. Next, spray a coating of dark sienna mixed with crimson over the area of hair, and finish with a paintbrush and colored pencils. Be sure to soften the edge against the background. To paint the soap bubbles, circular stencils of different sizes should be cut out of heavy paper and applied to the areas that are shown in the original photograph.

Liquid masking for the lips, to paint the shine.

Retouching the hair with a paintbrush to define and highlight, adding shine to its texture.

MORE ON THE SUBJECT
• Skin tones **p. 80**
• Faces and hair **p. 82**
• Human figures with the airbrush (I) **p. 84**

For painting the soap bubbles use masks patterned from the enlarged photocopy.

The final result. This finished illustration is exquisitely finished and beautifully colored.

RETOUCHING PHOTOGRAPHS

Until a decade ago, the field of airbrush was limited to the retouching of photographs. Today, since photographic quality can be manipulated with the aid of computers, airbrushes are not as necessary as they once were. But long before this was possible, almost all photographic images used in commercial advertising were manipulated in different ways to change background, heighten or reduce the focus, highlight contrasts, bring out details, or even eliminate parts of the image.

The Applications of Retouching Photographs

In spite of the greater use of computer technology, airbrushes are still used for retouching photographs. For example, a new shine can be given to an antique object, eliminating imperfections or the wear and tear of the years. An airbrush is used to retouch photographs that cannot be improved or reshot, or when a portion must be eliminated or added.

Nowadays, there are colors available with extra fine pigment, both matte and gloss, which are especially made for retouching photographs with an airbrush. Ranges of warm or cold grays, either matte or gloss, are also available so that you can retouch black and white photographs.

Photographic images can be improved using the airbrush for retouching.

The result of retouching a photographic image with an airbrush.

In Between Painting and Photography

Retouching a photograph starts off with a photographic image to create a pictorial effect above and beyond the medium of photography. An original illustration done with airbrush also begins with a photographic image. The airbrush, by the nature of its tiny particles of color, is a medium halfway between photography and painting. The interchange of both these ways of creating an image allows for all kinds of creative and commercial possibilities. The limits between the two mediums, photography and airbrush, are practically indefinable and often quite blurred. Professional airbrush artists use them interchangeably.

In this picture the boundary between photography and airbrush painting come together to such a point that it is difficult to make out which shapes and colors belong to which media.

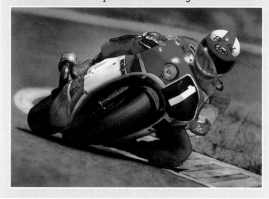

Modifying the Image

In general, retouching photographs tends to enhance the effects of shine and shade. Professional photographers anticipate these effects to be added by later retouching. Effects such as these cannot be obtained directly as they do not appear in the original model (whether it be a figure, a countryside scene, or an object). The airbrush is also frequently used to modify backgrounds, particu-

In advertising, high quality photographs can be changed and modified in many different ways thanks to retouching with the airbrush.

The backgrounds of this series of pictures have been modified with airbrush spraying.

Here the retouching slightly affects the skin tones and the contrasts between light and shade.

larly to paint out colors or figures that might accidentally appear. It can add by superimposing objects and figures as well. Often details that need to be retouched are only minor imperfections. These can be eliminated from a negative by using an opaque substance applied in the emulsion process, or scraped from transparent areas of the photographic emulsion. Common practice is to modify the image so as to give it a shine that it does not really have, a shine that is typical of airbrush painting.

dealing with an image that has to be reproduced. The background should first be masked so that you can work on the object or figure. You can then retouch the color of this background once the figure has been masked. Working with opaque colors will produce solid colors at first spraying and often does not require successive layers. It is important, therefore, to work with care so that the paint does not become too thick. The final retouches

are done with a paintbrush, outlining edges and boundaries between light and shade in order to obtain a polished, unblemished finish.

Advertising application of retouching photographs.

The Process of Retouching

A retouching process done with airbrush is approached in the same way as an original airbrush painting. The photographic copy should be big enough so that you can work from it comfortably. The colors should cover well so that the original defects of the photograph will be effectively hidden. You can use either matte or gloss gouache colors when

MORE ON THE SUBJECT

· Basic practice **p. 32**
· Using liquid masks **p. 38**
· Material **p. 48**

PROCEDURES FOR THEMES

COMMERCIAL PAINTING

The airbrush has a variety of applications. Retouching photographs, commercial painting, and the painting of advertisements and commercial illustrations are some of them. The guidelines and procedures outlined so far will produce highly polished and professional results in these areas.

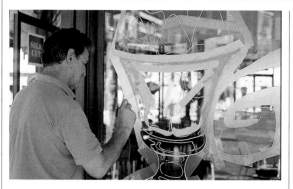

Airbrush work on glass means a preliminary drawing with a paintbrush using plastic paint. If you want to achieve the illusion of transparency, you must first apply a coat of white paint to the base.

Stencils for painting large outdoor images with an airbrush should be prepared in the studio and should be portable and flexible.

Commercial Painting: Store Windows

The airbrush is an excellent medium for the creation of commercial images, not only of those originals for reproduction but also direct paintings, those that are painted for the purposes of display. Store displays and the painting of glass store windows are such venues. Synthetic enamels are used for this kind of work as they are permanent colors that stick to the majority of nonporous surfaces. They have great covering capacity and an attractive glossy finish. Their finish makes them especially eye-catching and appropriate for this kind of illustration. Such images are painted directly onto the glass. The technique is the same as for any other kind of illustration except that the format is much bigger, requiring much larger areas of masking, fading, fixed and moveable masks, etc. The initial drawing is usually painted with plastic paint, which can be removed from the glass support with a damp cloth. As you are dealing with a transparent surface you will first have to

paint a white base in those areas that represent glasses and other transparent objects.

The relative difficulty of doing these paintings (working in the open air and on a vertical surface) is somewhat compensated for by the greater size of the details and the subsequent speed of finishing the work.

When working vertically and on a large scale, many of the details can be painted freehand.

The final result of a commercial painting done with an airbrush.

Illustration

CD and book covers, movie theater posters, and posters in general are other fields of commercial illustration. In these disciplines the technical capability of the artist plays as important a role as does creativity. Given that the airbrush is an extremely realistic medium, the artist does well to become proficient in its techniques, increasing one's versatility and marketability as a commercial artist. Airbrush images are, after all, impossible to obtain with photographic or any other media. It is a kind of "realistic magic" the only limits of which are your imagination and technical skill.

Many artists have achieved their greatest recognition in airbrush. Some of the most famous in the field have been noted for their work on CDs, book covers, and movie posters.

Illustration by Philip Collier. Airbrush has the capacity to depict fantasy as does no other medium.

This image by Yoichi Hatakenake combines impeccable photographic realism with a surrealistic theme of great dramatic strength.

MORE ON THE SUBJECT
• Color **p. 22**
• Oil and cellulose colors **p. 24**
• Material **p. 48**

This illustration, by Evan Tenbroek Steadmnan, owes its impact to the combination of dramatic illumination and the treatment of the surfaces.

Commercial Illustration

When doing commercial illustration the message must be absolutely clear. This being the priority, the commercial artist can design an image that is strong thematically and technically. The strength of the image and style and execution of the work will ultimately rest on the artist's creativity.

Illustration by Miquel Ferrón for a commercial enterprise. In this image, the clarity of the message is combined with the attractiveness of its style.

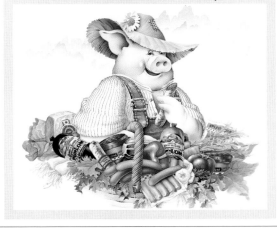

T-SHIRT PAINTING AND THREE-DIMENSIONAL FIGURES

These are other uses to which the airbrush is usually put. In the case of T-shirts and clothing in general, the airbrush gives a far richer result than silk-screen printing (the procedure usually followed in this type of manufacture). In the case of three-dimensional figures, the airbrush is usually an industrial spray gun, which allows the coverage of large areas or the mass production of items that are all the same.

Painting on Cloth

Items of clothing such as shirts, T-shirts, or blouses, whether they be made of cotton, linen, silk, or synthetic fibers, can be painted with an airbrush using special paints. Usually decorative motifs on cloth tend to be much simpler and more schematic than a formal illustration. The surface of cloth has a coarser texture than paper, and the coarser the texture the less detail can be shown. But motifs on T-shirts and clothing are seldom meant to be read as realistically as an illustration. Creases and the movements of the wearer would impede this. This type of painting has to be simple, brightly colored, and decorative in theme.

To paint T-shirts with an airbrush, place the T-shirt on a wooden support, so that the cloth is flat and free of creases. The shirt should not be stretched, but simply fastened, to avoid any distortion of your design upon removal from the board.

Normally, you can use simple techniques for painting on cloth. Moveable masks and a few colors will go a long way to create attractive, decorative motifs. Simple stencils are also good tools for this purpose.

Paints for cloth dry relatively quickly, but tend to leave the cloth stiff, as though it were starched.

To open up the weave of the cloth and soften it, iron the T-shirt through a damp cloth.

To paint T-shirts use large, simple masks. Stencils can be cut out of a piece of paper or card.

Create the basic design from the stencil and a few colors.

Three-dimensional Figures

The airbrush is often used to paint three-dimensionally molded figures, particularly in toy manufacturing, and is used in industrial painting in general. China and plastic dolls

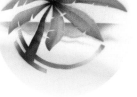

Finish the picture freehand.

Designs on T-shirts should be simple so that they remain visible even though the material creases.

MORE ON THE SUBJECT
• Basic Practice **p. 32**

Manual Processes

This series of masks was made using industrial procedures. Each had to be painted individually, with attention to their distinctive features. Though they are commercial products they are also unique works, colored by hand and requiring all the skill of an airbrush artist, including color mixing and freehand drawing techniques.

can be airbrushed with acrylic paints. Latex, plastic, cardboard, or papier mâché masks and figures, and toys of other materials can be airbrush painted with acrylic and synthetic enamels, either matte or glossy. The tool most commonly used for this type of work is the industrial spray gun, similar to those used in auto body shops. The pistol airbrush is also used. It is more sophisticated but does not give the same quality or precision as the artistic airbrush. Most of these figures and toys are airbrushed freehand, without the use of masks. There are times

The masks are painted one by one. Their processing is not as industrial as many mass-produced items.

when masks are used in commercial production as well.

In industrial airbrushing molds are used instead of stencils to mass-produce items.

The finish must be the same on each item produced.

For large figures spray guns are used that hold a lot of paint but are not very precise, as here precision is not needed.

The finish on a three-dimensional figure does not require the realism of a flat illustration.

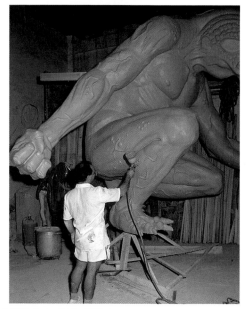

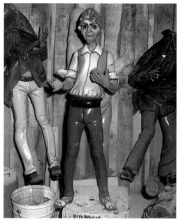

CONCLUSION

REVIEW

The following is a review of the most important points to bear in mind when painting with an airbrush. The 20 points that follow are techniques that have been fully developed in the preceding pages. The text that accompanies each illustration summarizes these techniques.

1

1. *Press downward on the finger lever to get more or less air, and backward to get more or less paint.*

2

2. *The airbrush must be thoroughly cleaned. Remember that a blocked nozzle should be cleaned out with a stiff paintbrush and the appropriate solvent or thinner for the type of paint used.*

3

3. *Keep a check on the oil level of the compressor and make sure that it is always up to the right level by looking at the gauge on the side. Change the oil at least once a year.*

4

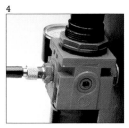

4. *The air hose must be properly connected to the outlet. If it is not tightly screwed in, air will escape from its edges and a lot of pressure will be lost.*

5

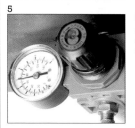

5. *The air outlet is regulated through the main pressure gauge. Do not exceed approximately 20 to 45 lbs. per square in. of pressure for small jobs.*

6

6. *Every time you finish a job, it is a good idea to drain the compressor. In order to do this you should push up the cup situated underneath the manometer to get rid of impurities.*

7

7. *Each type of paint has its own specific thinner; for inks and watercolor, it is water; acrylics need acrylic thinner.*

8

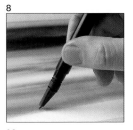

8. *Use a well-sharpened cutting tool. Don't press down too hard when cutting to avoid damaging the paper.*

9

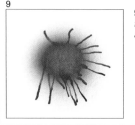

9. *When painting very close to the paper, control the air pressure and the color with the finger lever.*

10

10. *Practice every kind of brushstroke until the airbrush does what you want it to.*

11

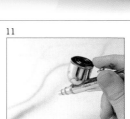

11. *You can make a raised mask with a piece of thick paper or board, stiff enough to lift, without the air from the airbrush being too near to its base.*

12

12. *Moveable masks are made from paper. Cut out to adjust perfectly to the contours you need.*

13

13. *Self-adhesive masking film is essential for all detailed jobs that require covering and uncovering different areas repeatedly.*

14

14. *Masking fluid is used to reserve small details that are too fine for ordinary masks.*

15

15. *Use a well-sharpened pencil and light lines to avoid grooving the paper. Remember that the preliminary drawing is essential to developing the final illustration.*

16

16. *All smooth surfaces need masking tape margins so that the edges remain clean and straight.*

17

17. *Mistakes can be covered over with white gouache. The corrections can be oversprayed with color.*

18

18. *Make a careful scheme of the area you are going to cut out with your cutting tool. A clear, well-defined drawing is essential.*

19

19. *Retouching or outlining with a colored pencil will add fine finish to your piece. Careful touching up will give the piece a sleek, professional look.*

20

20. *White spaces can be achieved in different ways. The most effective way of erasing is to use an electric eraser. The use of razor blades and white overpainting are last resorts.*

Original title of the book in Spanish: *Aerógrafo*.
© Copyright Parramón Ediciones, S.A. 1999—World Rights.
Published by Parramón Ediciones, S.A., Barcelona, Spain.
Author: Parramón's Editorial Team
Illustrators: Parramón's Editorial Team

Copyright of the English edition © 1999 by
Barron's Educational Series, Inc.

All rights reserved. No part of this book may be
reproduced in any form, by photostat, microfilm,
xerography, or any other means, or incorporated
into any information retrieval system, electronic or
mechanical, without the written permission of the
copyright owner.

All inquiries should be addressed to:
Barron's Educational Series, Inc.
250 Wireless Boulevard
Hauppauge, New York 11788
http://www.barronseduc.com

International Standard Book No. 0-7641-5161-4

Library of Congress Catalog Card No. 99-62171

Printed in Spain

9 8 7 6 5 4 3 2 1

Note: The titles that appear at the top of the
odd-numbered pages correspond to:

The previous chapter
The current chapter
The following chapter